BARRY CRAIG

ART AND DECORATION
OF CENTRAL
NEW GUINEA

SHIRE ETHNOGRAPHY

2

Cover photograph
The Tifalmin cult house at Bulolengabip in 1964. The carved and painted boards on the facade of this house are now in the Musée des Arts Africains et Oceaniens in Paris.

British Library Cataloguing in Publication Data available.

Published by
SHIRE PUBLICATIONS LTD
Cromwell House, Church Street, Princes Risborough,
Aylesbury, Bucks HP17 9AJ, UK

Series Editor: Bryan Cranstone

ISBN 0 85263 941 4

First published 1988

Set in 11 point Times and printed in Great Britain by
C. I. Thomas & Sons (Haverfordwest) Ltd,
Press Buildings, Merlins Bridge, Haverfordwest, Dyfed.

Contents

LIST OF ILLUSTRATIONS 4
1. INTRODUCTION 5
2. THE PEOPLE 13
3. HOUSES, SETTLEMENT PATTERNS AND RELIC AND TROPHY ARRAYS 24
4. HOUSEBOARDS AND WARSHIELDS 31
5. OTHER DECORATED OBJECTS 45
6. SYMBOLIC SIGNIFICANCE AND FUNCTION OF ART AND DECORATION 56
7. RELATIONSHIPS WITH NEIGHBOURING STYLES OF DESIGN 62
8. FURTHER READING 68
9. MUSEUMS TO VISIT 70
INDEX 71

Acknowledgements

I wish to acknowledge that the impetus for my interest in material culture and tribal art derived from Bryan Cranstone, who visited central New Guinea in 1963-4 whilst he was an Assistant Keeper at the British Museum. Further encouragement to follow this specialisation was provided by Mervyn Meggitt (then of the Anthropology Department at the University of Sydney) and Jack Golson (Prehistory, Australian National University). Donald Brook, now at Flinders University in South Australia, has improved my understanding of art and how to analyse it.

Financial assistance to extend my interests has at various times been provided by the Wenner Gren Foundation for Anthropological Research (my thanks to Lita Osmundsen), the Australian Museum (Sydney), the Museum für Völkerkunde (Berlin), and the Rijksmuseum voor Volkenkunde (Leiden).

Thanks are due to many Papua New Guineans who have patiently assisted with information and interpreting, in particular Dakamdapnok and Ferepnok of Telefomin.

All photographs and other illustrations are by the author, except figures 19 and 20, which are by B. A. L. Cranstone and the property of the Museum of Mankind.

I dedicate this book to the memory of Dakamdapnok, who died in 1972.

List of illustrations

1. Map of New Guinea island *page 6*
2. Bolobip houseboard first photographed in 1927 *page 9*
3. Shields collected in 1936 *page 11*
4. Language groups and tribes of central New Guinea *page 12*
5. Three generations of Wopkeimin males *page 15*
6. Kauwol man and women *page 16*
7. Supreme cult house at Telefolip *page 19*
8. Supreme cult house at Bultemabip *page 19*
9. Male *ot-ban* initiates dance at Telefolip *page 21*
10. Kauwol man wearing *sel* headdress *page 22*
11. Ancestral relics in *unangam*, Telefolip *page 23*
12. Typical Telefol house *page 25*
13. Ubtemtigin and ideal Telefol village plan *page 26*
14. Cult house at the Falamin village of Yogavip *page 27*
15. *Amdolol* walling compared to arrow binding *page 28*
16. Fegolmin ancestral relic and trophy array *page 29*
17. Telefolmin man cutting out a houseboard *page 32*
18. Telefolmin man binding stone adze blade to haft *page 33*
19. Marking out design on houseboard *page 34*
20. Carving relief on houseboard *page 35*
21. Defensive use of shield *page 36*
22. Recently made shield used as door *page 38*
23. Bordering elements of designs *page 39*
24. Major design types on shields and houseboards *page 39*
25. Shield of Derolengdam, Telefolmin *page 40*
26. Shield of Elip valley, Telefolmin *page 40*
27. Om River (Dulanmin) shield *page 41*
28. Shield of Magalsimbip, Wopkeimin *page 41*
29. Shields of Ulapmin and Tifalmin *page 43*
30. Cult house at Bulolengabip, Tifalmin *page 44*
31. Arrows and carving tool *page 46*
32. Method of obtaining arrow design rubbings *page 47*
33. Arrow designs and their meanings *page 48*
34. Five structural principles of arrow designs *page 49*
35. Atbalmin man wearing *teruntet* paint container *page 51*
36. Bamboo eartube/paint container and designs *page 52*
37. Taro scraper and palmwood club designs *page 54*
38. Painting of lizard in rock shelter *page 55*
39. Anthropomorphic meanings of shield designs *page 57*
40. Shields and ancestral relics in cult house *page 59*
41. Skulls and other human bones in cave *page 59*
42. Women's skulls in Falamin *unangam* *page 61*
43. Form and designs of shields, West Sepik area *page 62*
44. Distribution of arrow designs in West Sepik *page 64*
45. Smoking tubes of the West Sepik area *page 65*
46. Similarities between smoking tube designs *pages 66-7*

1
Introduction

The island of New Guinea has more diversity of language and culture than anywhere else in the world. The population of between 4.5 and 5 million Papuans and Melanesians speaks about one thousand languages and has developed about three hundred distinct cultures.

The Dutch established the first European settlement in West New Guinea in 1828 and retained control of the western half of the island until it became an Indonesian province in 1962. The eastern half of the island was apportioned between the British and the Germans in 1884. In 1907 Australia took over the administration of the southern section (Papua) from the British and, in 1914, took the northern section from the Germans. This territory was administered under a League of Nations mandate, then became a United Nations Trust Territory administered by Australia jointly with Papua. In 1975 Papua New Guinea attained independence.

The island of New Guinea (figure 1) is shaped rather like a large bird, hence the name given by the Dutch to the extreme western end: Vogelkopf, or 'Bird's Head'. Down the centre of the island, from end to end, runs a spine of high mountains; the highest, at 5000 metres (16,400 feet), is the Carstenz, which is covered with perpetual snow. At the very centre of the island, straddling the international border between Irian Jaya and Papua New Guinea, are the Star Mountains, named by a Dutch military expedition in 1910. From these mountains rise four of the larger river systems of the island of New Guinea: the Sepik, joining the sea on the north-east coast; the Fly, entering the sea on the south-east coast; the Digul, flowing to the south-west; and the Idenburg-Mamberamo, flowing to the north-west.

The western end of the Star Mountains is dominated by snow-capped Mount Juliana (Mandala) at 4700 metres (15,400 feet), north-west of the Sibil Valley. The eastern end of the Star Mountains is marked by Virgo at 3000 metres (9850 feet). This peak is just west of Telefomin, a government station and airstrip in an open highland valley at 1465 metres (4800 feet). This valley, Ifitaman, is the upper source basin of the Sepik River. Further east again lies the Strickland Gorge, forming a deep gash in the southern flanks of the Central Range.

Most of the people who live in the vicinity of the Star

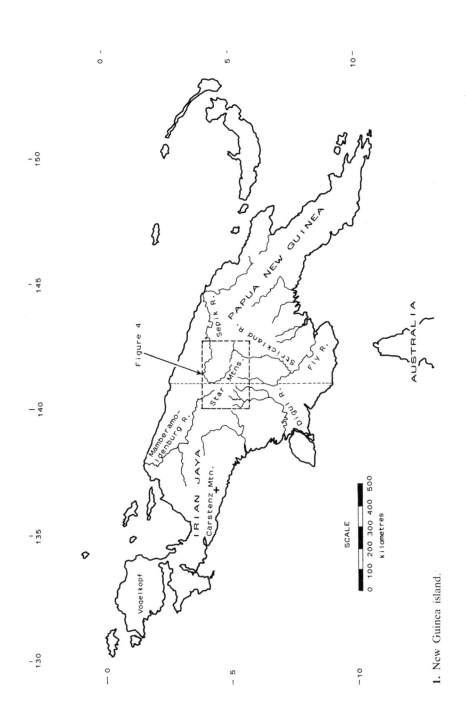

1. New Guinea island.

Mountains speak a sub-family of Papuan languages that has been termed Mountain-Ok (*Ok* means 'water' or 'river'). A related sub-family of languages, Lowland-Ok, is spoken by people to the south, in the lowlands of the Upper Fly-Digul River systems. The cultures in the highlands west of Mount Juliana (Mandala) are more like the Mountain-Ok culture than are those cultures to the east of the Strickland Gorge. The peoples to the north and south are living in lowland swamps and riverine conditions and consequently many aspects of their cultures are quite different from that of the Mountain-Ok. Linguistically and in some aspects of material culture, the affinity is with those to the south and south-west whereas with respect to the decorative styles on various objects such as shields, arrows and bamboo tubes the affinity is with the lowland peoples of the north. This suggests that the cultural history of the Mountain-Ok is most complex.

European exploration of the area provided the earliest records of the Mountain-Ok and their culture. The first European to enter the territory of the Mountain-Ok was Dr Leonhard Schultze-Jena who in 1910 was determining the boundary between the Dutch and German sections of New Guinea. He ascended the Sepik River into the territory of the Atbalmin.

However, it was Richard Thurnwald, the intrepid German anthropologist and explorer, who made the first contact with the people during his ascent of the Sepik beyond Schultze-Jena's furthest point to reach Ifitaman (the territory of the Telefolmin) and the source of the Sepik in the territory of the Falamin. He described the first contact between a white man and the Mountain-Ok (Thurnwald 1916):

'As the path emerged from the bamboo thicket, we found ourselves unexpectedly in front of a village of five houses. A little boy with a big stomach and a lot of dirt on him was chasing eagerly after a butterfly. I stood there waiting a long time before he noticed me. He caught sight of me, stared for a minute, then ran away with a cry of horror. A man, just coming out of a house, fled into the forest howling with fear. The doorways of occupied houses were hastily barred . . . then all fell silent. I went up, knocked at the doorways and spoke, putting knives, glass beads and rings — the usual presents — in front of the houses in which I suspected there were people. But in vain; nothing stirred.'

Perhaps because of the strangers' interest in their decorated objects, the Telefolmin called Thurnwald and his party *futmin* (literally 'design-people'). Thurnwald reports:

'In the evenings the inhabitants of the nearby villages came up

and sat together with my carriers . . . and bartered things with each other. They offered my carriers arrows and decorative objects, while my carriers made them happy by giving them red calico strips and glass beads. So we finally parted from each other in peace and great friendship.'

Strangely, however, Thurnwald did not mention the distinctive carved and painted boards fixed at the front of most houses, nor is it clear whether he himself obtained any of the artefacts for an ethnographic collection. Nothing of that nature appears to have survived to the present time.

The next white man to be seen by the Mountain-Ok did not come along the Sepik but along the rivers from the south. In 1922 Leo Austen, a government patrol officer, followed the Alice or Ok Tedi to the base of the Star Mountains and, during his second trip of 1924, he saw two men who came from the mountains to the north, most likely Faiwol speakers.

Exploration of the headwaters of the Fly was not accomplished until Charles Karius and Ivan Champion were sent by the Papuan administration to trace the Fly to its source, cross the Central Range to the head of the Sepik and follow that river to its outlet on the north coast. In 1927 Karius and Champion arrived at Bolobip. This Angkeiakmin village is situated beneath the southern wall of the Hindenburg Range which separates the headwaters of the Fly and Sepik rivers. Here they photographed the first houseboard seen during the journey (figure 2). Champion (1966) reports:

'I noticed at one end of the village a house about 30 feet long and 15 feet wide. Its entrance was closed by flat boards on which some effort had been made to paint a design in red and blue [sic] pigment, but this had been exposed to the weather so long that I was unable to see what it represented. The carriers started to put up their fly near this house but they were stopped and asked to select another site. This puzzled and interested me, so I went up to the Chief and pointed to the house with a questioning look. He appeared very solemn, looked to see if the women were watching, and then leaned over and whispered "Amawk, Amawk". "Amawk?" I asked. "Amawk!" he whispered again and indicated that the men foregathered there with great feasting of taro . . .'

After resting at Bolobip and obtaining guides, Karius and Champion set out to cross to the headwaters of the Sepik. They clambered precariously upwards through mist and rain, over plunging chasms festooned with moss-forest, suffering from the

2. Houseboard photographed by Champion in 1927 at Bolobip village, here photographed in 1967. By 1981 it had been discarded.

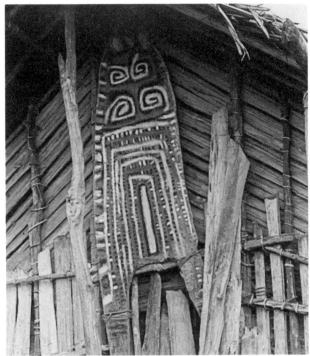

bitter cold and penetrating dampness. Then five days later:

'The rain ceased, giving way to lukewarm sunshine which was growing stronger. Now and again we caught a glimpse of a large valley showing through the forest. It lent speed to our footsteps.

'Out into the bright sunlight we stepped to gasp at the sight before us. We were standing on a small grass plateau looking at what I thought was the most beautiful sight that one could ever wish to see. Several thousands of feet below us was a great basin surrounded by mountains and through this basin, bordered by casuarina trees, meandered a slow flowing stream. On a projecting rock stood Tamsimara (their guide) pointing to the valley and calling "Wok Takin! Wok Takin!" (Water Sepik! Water Sepik!).'

The explorers descended into the valley and met the Falamin, the people to the east and enemies of the Telefolmin. They moved west through Telefolmin territory, followed the Sepik downstream through Atbalmin country and, after many more adventures, met the motor yacht *Elevala* at the junction of the

October and Sepik rivers.

There are few remarks on the material culture in Champion's book but he does mention the houseboards and arrows:

'The houses were the same as those of the Feramin (Falamin), and we counted fifteen of them, besides the men's club-house, arranged on each side of the street, the club-house being at one end, its entrance blocked with pigmented slabs of wood, and the surroundings planted with crotons . . . their arrows were of extraordinary design, most of them having broad blades of bamboo, the middle portions of which were cut out like fretwork.'

To both Thurnwald and Champion, the Sepik source basin seemed fertile and populous. However, weeks of struggling through scarcely inhabited forest may have influenced their judgement. Telefolmin population density is just over one person per square kilometre (three people per square mile) and much of the valley floor is badly leached, swampy soil incapable of growing anything but rank grass. This compares quite unfavourably with the fertile highland valleys to the east, which support population densities of over forty people per square kilometre (over one hundred per square mile).

Thurnwald saw that the economic future of the area depended upon the minerals that might be found there. Others evidently thought the possibility at least worth investigating and in 1935 J. Ward Williams mounted an expedition on behalf of American and British mining interests to search for gold in the Sepik headwaters. His team consisted of seven other Europeans, including an Australian pilot, Stuart Campbell.

Preliminary aerial reconnaissance and ground survey of the upper Fly River area was pursued in 1935 and the flat valley floor, on which several of the Telefolmin villages were situated, was chosen as the only suitable place where an airstrip could be made in a short time. As it could be seen that the flat grassy areas were quite boggy, a ground party walked in from the Fly River and prepared the surface by draining and levelling. A narrow strip 40 metres wide and 400 metres long (43 by 430 yards) was built. Over the next eight months the vast territory encompassed by the headwaters of the Sepik, and its tributary the May, were thoroughly prospected but no payable deposits of alluvial gold were found.

Despite the disappointment, Campbell and Williams collected ethnographic material which they gave respectively to the Australian Museum in Sydney and the Los Angeles County

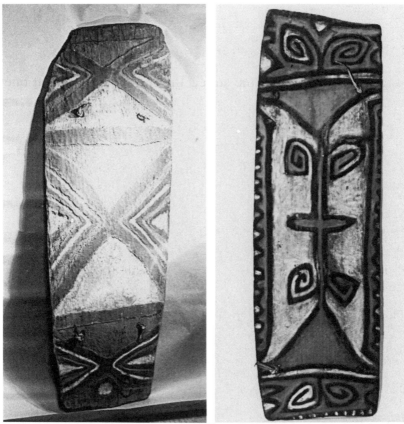

3. Shields collected in 1936 by J. Ward Williams (left), now in the Los Angeles County Museum of Natural History, and by Stuart Campbell (right), now in the Australian Museum in Sydney.

Museum of Natural History. These were the first artefacts known to have been collected directly from the Mountain-Ok and included a few warshields (figure 3) but no houseboards. No doubt the length of the houseboards made them too difficult to transport. Notes on the Mountain-Ok people and their culture were published by Campbell (1938) and by Kienzle and Campbell (1938), together with some photographs. These remained the fullest and most reliable published data on the people for almost thirty years.

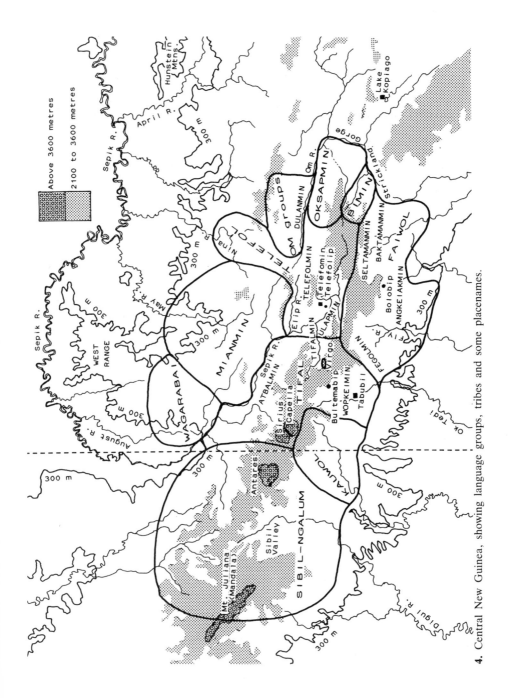

4. Central New Guinea, showing language groups, tribes and some placenames.

2
The people

The Mountain-Ok may be divided into several language groups (figure 4) each consisting of a few named groups characterised by the suffix *min* (meaning 'people'). Thus, the Telefolmin, Falamin and Ulapmin speak Telefol; the Atbalmin, Wopkeimin and Tifalmin speak Tifal; the Angkeiakmin, Seltamanmin and Fegolmin speak Faiwol, and so on. The groups in Irian Jaya speak Sibil and Ngalum, which appear to form a western sub-family distinct from the Mountain-Ok in Papua New Guinea. The Oksapmin, the easternmost group, and the Om River groups north of them speak languages distinct from Mountain-Ok languages but many aspects of their culture are closely related to that of the Mountain-Ok.

Within these -*min* groups are smaller -*min* groups which are land-based kin groups consisting of one or more villages. Villages vary in size from two or three houses to twenty or more. The Oksapmin differ from the other Mountain-Ok and do not live in villages but in scattered homesteads.

The Mountain-Ok number around thirty thousand people. The larger -*min* groups (or 'tribes') each number between three hundred and three thousand people. The smaller -*min* groups (or 'parishes') do not normally exceed two hundred people each. Villages vary between thirty and one hundred and fifty people. Marriage within the village is preferred although a small number of marriages do occur between villages, between parishes and between tribes. Where this occurs, the cognatic system of descent and inheritance (determined on the basis of relationships traced through either parent) provides the links for people to move to other villages, parishes and tribes. Other links beyond the tribe are created for the purposes of trade and trade partnerships may be inherited. Some of the Mountain-Ok determine descent and inheritance patrilineally, on the basis of relationships traced through the father.

In general, enmity prevails east-west, between people who occupy similar ecological niches; trade occurs north-south, between people who occupy dissimilar ecological niches. Even the type of stone adze blade, called *fubi*, which comes from the quarries in the highlands far to the west in Irian Jaya, is traded along a more or less zigzag route between dissimilar ecological niches.

The material culture of the Mountain-Ok people is based on natural materials such as stone, bone, plant fibres and timber products. Stone blades derive from three quarry sources, the major one being in Irian Jaya. These blades are hafted as adzes rather than as axes. Small flakes of chert function as hand-held knives. Pigs' tusks serve as scrapers; cassowary leg bones yield chisels and gouges; bamboo slivers are used for butchering game and pigs; rats' teeth are useful for detailed carving (of arrow points and designs) and for etching designs on bamboo tubes.

Bows of black palm and unquilled arrows are the main hunting and fighting aids. Various types of traps are used to catch animals. Other weapons used include the black palm spatulate club, the hafted stone-headed club (disc, ball, star or 'pineapple' shapes) and, for protection, the board-like shield and woven cane body armour. There are only two musical instruments — the bamboo Jew's harp and the hourglass-shaped hand-drum. These may only be used by men and only after reaching a certain stage of initiation.

On his penis the male wears a gourd, 100 mm to 250 mm (4 to 10 inches) long and often curved, held in place by a string around his hips; he very often also wears a length of cane wound several times around his hips (figure 5). The female wears a very short layered skirt of reeds consisting of front and rear sections which leave the thighs completely bare (figure 6). Both sexes wear any number of ornaments consisting of strung shells (*nassa,* cowries and freshwater mussels) and the teeth of pigs and dogs; *conus* shell necklaces; necklaces, chest, wrist and ankle bands incorporating the seeds of *Coix lacryma* (Job's tears); very rare pearl shell and bailer shell necklaces; and various types of feather ornaments (black from the cassowary, white from the cockatoo and red from the parrot); various bird-of-paradise species yield plumes and often the entire pelt is used. Possum and cuscus pelts may also be worn on the forehead.

Cassowary quills may be looped and worn as earrings or necklaces; boars' tusks are also used for these purposes. Through holes in the nostrils the men may insert cassowary quills tipped with white cockatoo feathers, the head-parts of the rhinoceros beetle or short sticks; a limestone peg or a pair of boar's tusks may be worn through the pierced nasal septum. Dogs' teeth may be strung as necklaces and belts; their rarity gives them high value for bride price and trade purposes.

One of the most important artefacts is the flexible, looped string bag made by the women. They use hand-spun bark fibres

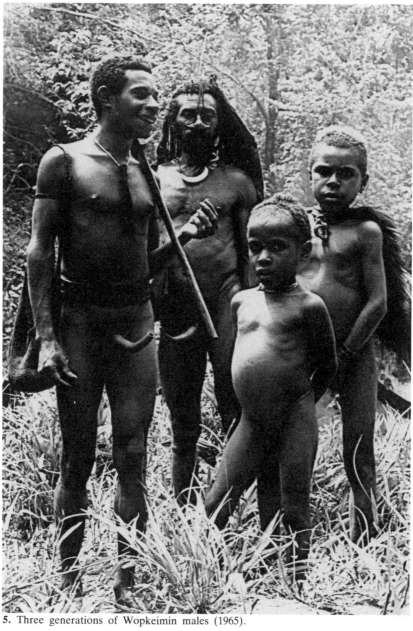

5. Three generations of Wopkeimin males (1965).

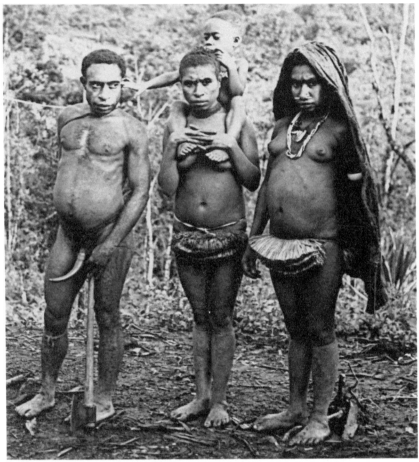

6. Kauwol man and women (1965).

formed into a strong two-ply string. These bags, called *bilums* in Papua New Guinea, are made in many sizes and shapes. The largest are used by women to carry firewood and food from the gardens. Babies may be carried in them and ancestral bones are kept in them, thus providing a rich source of metaphor associated with the womb, and with birth and death. Small, tightly woven *bilums* contain personal hunting charms and amulets. Bedecked with certain types of feathers (for example, those of the eagle, the cassowary and the cockatoo), they signify male ritual status. An empty *bilum* worn over the back and shoulders serves as a cloak

on cold days. Some groups make cloaks from a crude kind of tapa, a beaten barkcloth.

The usual method of making fire is to pull a length of split cane back and forth round a split stick, the split held open with a wedge and the tinder placed in the split at the point of friction. Another method is to strike two pieces of iron pyrites together to shoot a spark into a handful of tinder.

The Mountain-Ok are hunter-gatherers, swidden horticulturalists (clearing the ground by burning) and they domesticate the dog and the pig. Nowadays fowls are kept. Their staple crop is taro (*Colocasia*), although some groups, such as the Atbalmin, rely more heavily on sweet potato. Even where taro is the staple, sweet potato is an important crop for pig forage.

The sophistication of pig husbandry is directly related to the degree to which hunting resources have been depleted. Thus pioneering groups in areas where hunting resources are abundant have little need for elaborate pig husbandry: they simply raise wild piglets found in the bush. Taro cannot be fed to pigs without being cooked, which limits the size of the pig herd. However, with the relatively recent introduction of sweet potato (no more than three hundred years ago), this limit was removed since sweet potato can be fed to pigs without being cooked. Indeed, the pigs can be turned loose into the sweet potato gardens to forage for themselves.

The introduction of sweet potato probably provided the basis for a boost in population and this is confirmed by oral tradition. The Telefolmin of Ifitaman have developed the most sophisticated techniques of pig husbandry of all the Mountain-Ok and their history since the late nineteenth century has been expansionist. In response to the burning down of their supreme cult house at Telefolip in about 1870, they invaded the valley inhabited by the perpetrators, a group named the Iligimin. They killed all the able-bodied men and subsumed the rest of the population into their own colonising groups, probably doubling their numbers within a century.

The Telefolmin appear to be the most central of all the Mountain-Ok, at least of those 'tribes' in the Papua New Guinea section of the Star Mountains. They are central in myth and their supreme cult house is acknowledged by all the surrounding tribes as a kind of Mecca in the context of their religious cults. To some extent this view is reinforced by the fact that the government sub-district office is situated at Telefomin, the Baptist Mission is based there and there are a small hospital, a primary school and a

high school. The airstrip at Telefomin is the largest in the area, except perhaps for that at Tabubil, the base for the huge Ok Tedi Mining Company, which is exploiting a gold and copper deposit in the territory of the Wopkeimin. This new activity threatens to shift the centre of the Mountain-Ok world away from Telefomin to the territory of the guardians of the supreme cult house at the village of Bultemabip.

The supreme cult house of the Telefolmin in the village of Telefolip (figure 7) and that of the Wopkeimin in the village of Bultemabip (figure 8) were, according to myth, both established by Afek, the Old Woman, the founding ancestress of all the *-min* tribes. The cult house at Bultemabip is believed to have been built by Afek prior to that at Telefolip, but Telefolip is where she retired from her many creative labours, where she died and where her relics are believed to have been preserved.

Knowledge of the secret aspects of myth and religion are passed on to male initiands in a prescribed order in several successive ceremonies. The number of ceremonies and their details vary considerably from tribe to tribe, though there are some strong consistencies. Since it is not possible to deal with these variations here, a brief description of the initiation of the Telefolmin male will suffice.

The first stage of initiation of the Telefolmin male took place when the initiands were about five to eight years of age and most were fully initiated by their late twenties. This did not, however, mean that they had acquired all the available ritual secrets: that was a lifetime pursuit for the ritual specialist.

Although there was expression of sexual differentiation in the rituals, this was not overtly stressed. The initiands were secluded, many details of the rites were kept secret from the women and children and initiands were progressively removed from the habit of sleeping in the women's houses to sleeping in the men's houses.

In contrast to many Sepik River, Highlands and South Coast cultures, there was no mutilation of the genitals and no ritualised expression of fear or envy of female sexual functions (except that menstruating women must seclude themselves in a special hut built for the purpose outside the village circle).

Pain and discomfort were, however, characteristic of the rites and were inflicted by sponsors birching the initiands, beating them with stinging nettles, forcing them to sit close to blazing fires, showering them with hot ashes, forcing them to dance and stay awake for many hours, covering them with pig-grease and

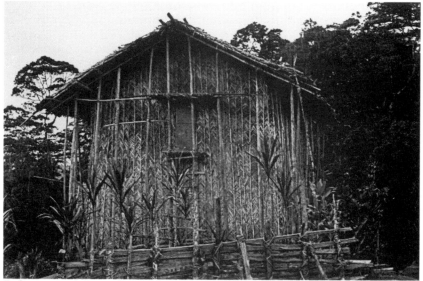

7. Supreme cult house (*amdolol*) at the Telefolmin village of Telefolip (1964, but still maintained).

8. Supreme cult house (*futmanam*) at the Wopkeimin village of Bultemabip (1967, but still maintained).

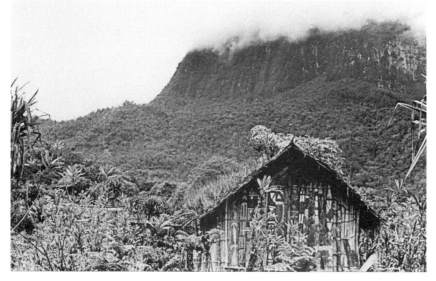

red paint and stuffing it up their noses and in their eyes and ears, and forcing them to sleep in seclusion without the warmth of a fire to dispel the chill of the highland dawn. There was also a great deal of moral instruction and the teaching of etiquette.

Another important aspect was the telling of a number of secret stories, most involving their founding ancestress Afek, the Old Woman. Men, women and children knew a number of myths but many of them consisted of three parts: a beginning, a middle and an end. The 'beginning' and the 'end' were public knowledge but the 'middle' was secret and revealed only to initiated males. Secret knowledge was taught by giving information which would be revised and re-presented at each successive rite; each time it was presented, the initiands were told that this was the truth, the whole truth. The basic method of knowledge acquisition was through revelation requiring the manipulation of ritual objects and substances, in particular certain hunted animals, in the context of songs and story-telling.

The rationale for the pain and discomfort of the rites was that it was payment for certain privileges being granted upon completion of each stage of the rites: admission into male society, the granting of secret knowledge and the removal of restrictions on eating certain foods.

Food and water taboos were enforced at all rituals because certain substances, particularly water, are inimical to the 'heat' (that is, power) of the ancestors. Initiands were 'shown' to the ancestors (youthful informants often said that the ancestral relics were 'shown' to them but older men made the converse statement) and there must be no impediment to their being blessed with ancestral goodwill. Not only were the initiands fed with foods believed to give them a strong and healthy appearance but the red paint and pig-grease on their skins were held to have direct magical properties conducive to health and strength. Cucumber was given to them to eat and crushed on their bodies so that they would grow quickly like the cucumber plant.

Several boys were initiated at one time. The earlier ceremonies would be carried out at the initiative of one village but invitations would be extended to other villages for sponsors to bring initiands. Such invitations were often accepted on behalf of those boys who may have missed the ceremony when it was last performed in their own village. However, the ceremony was basically a local affair. At successive stages in the series of rituals, the basis of participation widened until invitations to attend were accepted by individuals of other tribal groups for what amounted

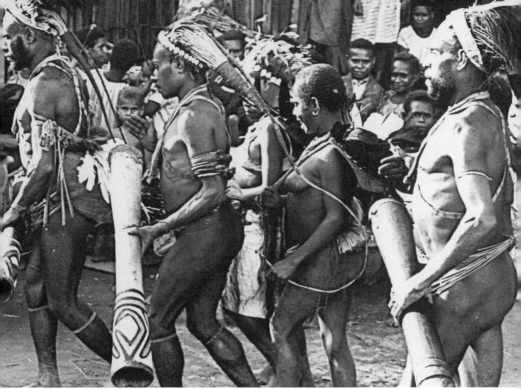

9. Male *ot-ban* initiates and a woman dance at Telefolip (1964). The men beat their hand-drums (*ot*) and wear the double-pigtailed *mafum* headdress.

to a Telefolmin ceremony with inter-tribal overtones.

Thus there was a group of boys in an intimate age-set of small size (they called each other *nafalop*) being integrated into larger and larger age-sets that cut across local groupings and provided the basis for many interpersonal relationships.

In the earlier ceremonies, the *dakasal-ban* and *om-ban,* the village cult house *(yolam)* was the building in which the more secretive aspects of the rituals were performed. The next rite, the *talalep-ban,* involved the use of a temporary structure only and a fenced-off gully to force the initiands to run the gauntlet. For the *mafum-ban* the initiands and sponsors gathered at the tribal ritual centre (the village of Telefolip) and the initiands' hair was bound into double pigtails, a smaller one on top of a fatter one, hanging down at the back (figures 9 and 10). This hairstyle is called *mafum.* The rites of the *talalep-ban* were repeated and followed by instruction in the social mores.

The *ot-ban* and *tap-ban* involved the use of the spirit house *(amdolol)* at the tribal ritual centre of Telefolip but any village could sponsor the ceremonies. The *ot-ban* granted the privilege of using the hand-drum *(ot)* and the Jew's harp *(talam).* The *tap-ban*

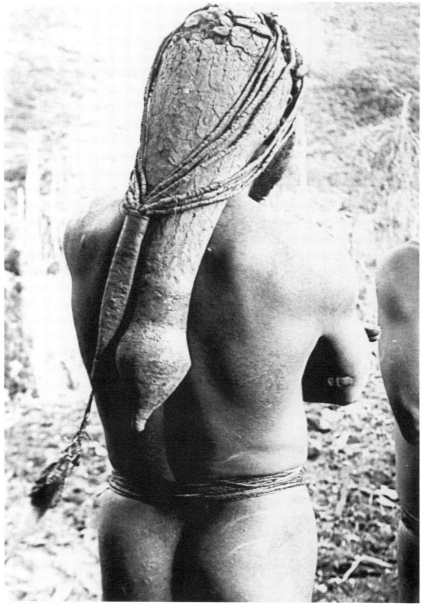

10. Kauwol man wearing *sel* (equivalent to Telefol *mafum*) (1965). The larger 'pigtail', though phallic in appearance, more likely represents the taro corm.

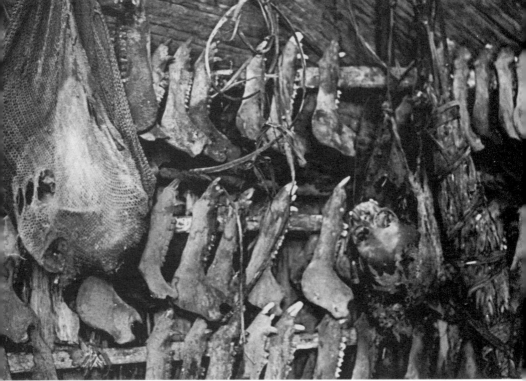

11. Ancestral relics, including skulls, in dilapidated string bags among pig jawbone trophies in an *unangam* (women's house) at Telefolip (1964).

completed the series of initiation rituals.

One of the most important functions of these last two ceremonies was to provide an opportunity for performing tribal-wide taro fertility rituals *(iman-ban)*. These involved the burying of certain ancestral bones beneath red cordyline bushes (palm lilies) planted for the occasion in selected taro gardens throughout the tribal territory. When the taro reached the appropriate stage of maturity the bones were retrieved with much ceremony and the major part of the initiation proceeded. Domestic pigs were killed at all initiation ceremonies and a portion of the pork was always offered to the ancestors.

The care of ancestral relics (figure 11), reflecting concern for the ancestors' welfare, was necessary to enlist their aid in pursuits of importance to the Telefolmin: gardening, hunting, pig husbandry and warfare. The initiation rituals served to introduce initiands to the secret aspects of the ancestor cult and to prepare them for the adult male role in their society.

3
Houses, settlement patterns and relic and trophy arrays

Perhaps the single most important artefact of the culture of the Mountain-Ok is the house, not only because it affords necessary shelter but also because the different names and functions and the spatial arrangement of houses, in villages and in relation to one another, provide many clues to the socio-cultural premises of the people.

Mountain-Ok houses (except for those of the Oksapmin) conform to a single architectural type (figure 12). This consists of one room 3 to 4 metres (10 to 12 feet) square with one or two hearths. In the west, the rooms have rounded corners so that they become almost circular. The roofs are gabled and thatched with leaves of the giant ginger plant, bamboo, grass or sago, depending on locally available materials. Eaves are generous and frequently project sufficiently in front of the house to afford some shelter to the doorway and a narrow verandah which is simply a continuation of the flooring beyond the front wall. Walls are of vertically placed timber lined inside with sheets of bark from the wild pandanus, palm or softwood trees. The floor is raised about a metre (3 feet) off the ground and lined with sheets of tough palm bark. The hearths are just over half a metre (about 2 feet) square, constructed in the floor with timber battens or woven cane supported by four corner-posts, filled with stones and finished off in clay like a large bowl. Firewood is dried in racks above the hearth. Smoke from the fires escapes slowly under the peak of the gable, front and rear, and the soot deposited by continuously burning hearth fires preserves the roofing materials from rapid destruction by insects and constant rain. It also provides the source for black paint.

Oksapmin family houses are built more crudely than are the houses of the other Mountain-Ok groups and have earthen floors. Their cult houses, however, are very like those of the other groups.

The Mountain-Ok make a primary distinction between house types on the basis of the sex of the persons using them: *unangam* (women's house) and *tenumam* (men's house). These are distinguished by their spatial arrangement in the village: the men's houses are clustered at one end of the village and must

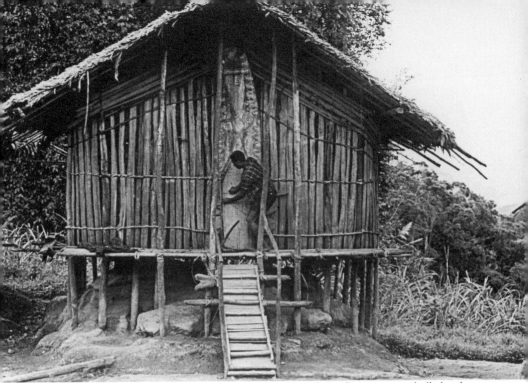

12. Typical Telefol house: in this case, on the site of the first *unangam* built by the founding ancestress Afek, at the Telefolmin village of Telefolip (1967). The houseboard (*amitung*) on this house is now on display in the Papua New Guinea National Museum.

always be higher (that is, upstream by reference to the closest creek) and higher off the ground than the women's houses, which are set in two parallel rows or a rough circle around a cleared space forming the village common (figure 13). The external walls of women's houses are built of split timber whereas the external walls of men's houses are built entirely of unsplit timber poles.

This separation of the sexes is believed to have been instituted by Afek. When she came to the site she later called Telefolip, she built an *unangam* and then the supreme cult house, the *amdolol*. She slept in the *amdolol* and her brother/husband slept in the *unangam*, but neither slept at all well. The next day Afek discussed this with her brother/husband and she suggested that he sleep in the *amdolol* whilst she sleep in the *unangam*. That night they both slept very soundly and so Afek pronounced the arrangement satisfactory. Thus the separation of the sexes in appropriate houses was instituted by the Old Woman herself.

The Mountain-Ok male often eats and socialises, and even sometimes sleeps, in the *unangam* but the *tenumam* is preferable because of male company and the peace and quiet owing to the absence of children and pigs. Further, while he is in the village, a

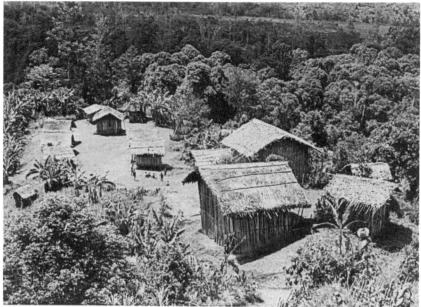

13. The Telefolmin village of Ubtemtigin in the Elip Valley (1967). The cult house (*yolam*) was built on the site of the supreme cult house of the vanquished Iligimin. This village conforms precisely to the ideal Telefol village plan (below).

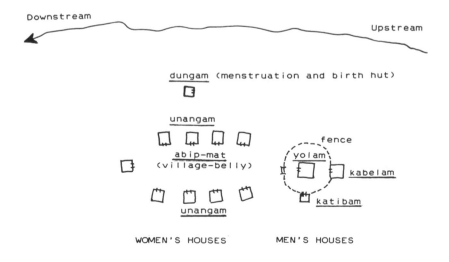

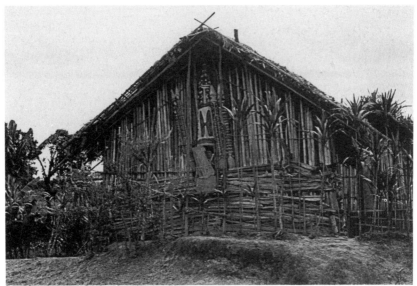

14. Cult house (*amoken*) at the Falamin village of Yogavip (1967). Note the horizontal walling at the base of the structure.

man's primary concern must be for the welfare of the whole village and concern for his family is a competing interest. However, this arrangement applies only to village houses. If a man wants to be with his family, he goes with them to one of their scattered gardens and they live together in the garden house (*sebam*). Brothers or sisters may choose to share a village house so personal privacy is not easy to achieve in the village. Garden houses provide much more personal privacy but sexual intercourse usually takes place in the gardens or the bush.

The next level of classification of village houses discriminates between the various types according to the ritual status of the men who may use them and the place of these houses in the tribal-wide hierarchy of cult houses. Thus most villages have a *kabelam* for the younger men. The term *kabelam* refers to the habit of the male hornbill (*kabel*) of interring the mother and young in a hole in a tree, feeding them through the hole until the chicks are ready for flight. This is a reference to the confinement of young male initiands in the house with their sponsors (the 'mothers') during certain stages of their initiation into the ancestor cult.

A *katibam* is built for the old, fully initiated men. Since there

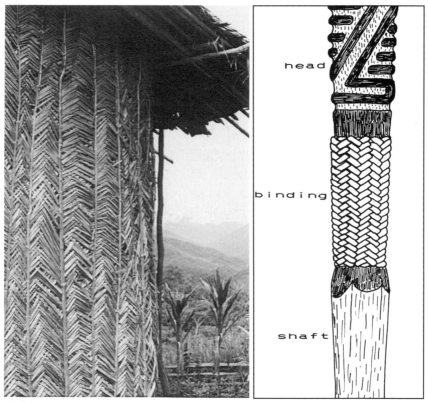

15. Detail of external wall cladding of *amdolol* cult house compared to *un-mib* arrow binding.

are relatively few older men, the house need only be small (*katip*), hence its name, 'small house'. The *yolam*, or cult house, contains the most important ancestral relics; its name appears to derive from the word *olal* meaning 'ancestors'. Small villages may combine the functions of all three types of men's house in the one house and call it the *yolam*. Other names for the *yolam* are *amabem* (literally 'house-taboo') and *amoken* (literally 'house-mother'); the latter term was recorded by Champion as *amawk*. Certain buildings habitually called *amoken* are higher on the cult-house hierarchy than other *yolam* and are distinguished by split timbers laid horizontally part of the way up the external walls (figure 14).

 Finally, at the top of the hierarchy, is the *amdolol*, the supreme

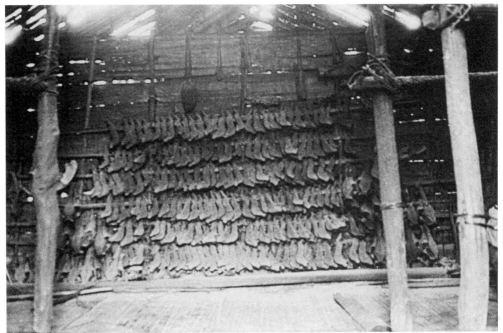

16. Ancestral relic and animal trophy array on rear inside wall of *kabelam* at the Fegolmin village of Bolang (1972).

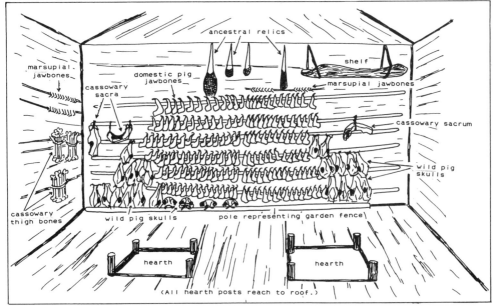

cult house. This house is distinguished by its external wall-cladding, vertically placed round poles sheathed with hundreds of thousands of short slats arranged in vertical series of chevron patterns, giving the appearance of vertical palm fronds. The cladding is referred to as *un-mib*, the plaiting that holds the head of an arrow (*un*) on to its shaft (figure 15). There are only two such buildings in existence: one at Telefolip, the first ancestral village of the Telefolmin, and one at the Telefolmin village of Ubtemtigin in the Elip Valley to the north of Ifitaman, on the site of the supreme cult house of the vanquished Iligimin (figure 13).

Besides the ancestral relics (skulls and other bones of men, and, rarely, women, who were particularly outstanding as hunters, fighters, gardeners or pig husbanders) there are also stored in the village houses domestic pig jawbones and trophies of the hunt: marsupial jawbones, wild pig skulls, cassowary leg bones and pelvises and the occasional crocodile skull. The ancestral relics, domestic pig jawbones and trophies of the hunt are arranged in a pattern that has significance in terms of the way the people exploit the various ecological zones from which the animals derive, the symbolic/ritual significance of these animals in the male cult and the interdependence of ritual with human exploitation of the ecology (figure 16). The details of the arrangement express visually the current theological position of the curator of the relics. These arrangements of relics and trophies may be regarded as the most profound art works of the Mountain-Ok (Craig 1988).

These 'works' are eligible for placement in women's houses, men's houses and cult houses among the Telefolmin, Falamin and Ulapmin. However, among the Faiwol-speaking groups on the Fly headwaters and the Wopkeimin of the Ok Tedi headwaters, these displays are never placed in the family houses, only in men's houses and cult houses. In other areas (Atbalmin, Tifalmin, Mianmin and Oksapmin), the display is set up only in the cult house at the group's ritual centre.

The village, then, is the location for communal life, for ritual and for displaying the ancestral relics which are of importance to the welfare of the community. The Mountain-Ok family balances its need for communal support with its need for privacy by moving back and forth from village dwelling to garden houses, spending days, weeks or even months at a time away from the village.

4
Houseboards and warshields

In many New Guinea societies the ancestor cult performances inspired a great deal of artistic woodcarving. This was not so among the Telefolmin and their neighbours, however. Apart from the beautifully carved designs on arrow foreshafts and etched designs on bamboo smoking tubes and paint containers, and the band of designs carved at the distal end of hand-drums, the woodcarving of these mountain people is restricted to the flat wooden fighting shields (*atkom*) and the surfboard-shaped planks (*amitung*) set over the tiny hatchways of the houses. In addition to an *amitung,* some cult houses have a number of carved and painted boards covering most, if not all, of the front wall and the cult house at Bultemabip on the headwaters of the Ok Tedi has carved and painted boards covering both front and rear external walls, unique for the Mountain-Ok.

The technology involved in the making of warshields and houseboards is the same and the designs on both artefacts may be identical or at least closely derivative the one from the other. In the context of the male cult, both objects have religious significance.

Materials and techniques

A softwood tree of suitable size is selected and felled. As a result of its fall it may split lengthwise. If so, the artisan can readily chop out a length of log and complete the split; if not, he must split it with wedges. He then chops away at the convex side of the half log until he has a rough plank about 2.8 metres long by 50 cm wide (9 feet by 20 inches) for a houseboard and about 1.6 metres long by 50 cm wide (5 feet 3 inches by 20 inches) for a warshield. The houseboard plank is pointed at one end and a hole about 70 cm by 40 cm (28 inches by 16 inches) is cut in the opposite (lower) end (figure 17). The houseboard is about 125 mm (5 inches) thick at the lower end and somewhat thinner at the top end; the shield is about 30 mm (just over an inch) thick all over.

Traditionally, stone adzes (*fubi, mok,* figure 18) were used to cut the planks and the amount of labour expended must have been considerable. This stage of the project often involved two or more men working together in a bush camp, sometimes not far from enemy territory, so they were keen to get back to the

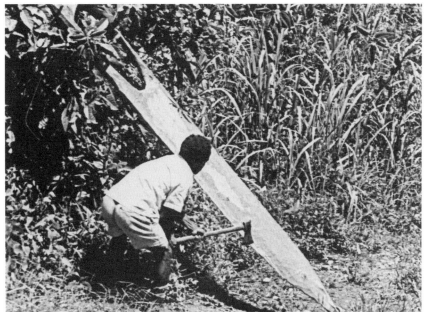

17. Telefolmin man cutting out a houseboard using a steel axe (1967).

village. Stone tools were last used soon after the arrival at Telefomin of a large American-Australian work force in 1944, which came to rehabilitate the airstrip built by the J. Ward Williams expedition. Steel axes were given in payment for labour and so the stone adzes were put aside.

After the board has been smoothed, it is carried to a nearby garden house or to the village and placed at the side of the house, underneath the eaves, to dry out. It may be bound with cane to prevent splitting. When the board is dry, the design is marked out with moistened soot on one side (figure 19). The whole surface, except for the black lines, is then chiselled out to a depth of about 8 mm (a third of an inch), leaving a raised pattern which is later repainted black (figure 20). The chiselling was once done with the stone adze and small hand-held unhafted flakes and blades; cassowary bone gouges were also sometimes used in the manner of a chisel, the wood being broken out splinter by splinter. Steel knives and chisels are used today.

Four colours are commonly used: red, yellow, white and black. The red is either from red ochre or clay found in Ulapmin territory and obtained by trade or a red iron deposit found in

water seepages, a ferrous compound associated with micro-organisms. The colour can be intensified by burning the sub-stance on red-hot coals. It may then be crushed to a powder and applied with a little moisture. The ochre is called *bakan* (which is also the general term for 'ground'). The seepage substance is called *inalol*, a term now applied to rust on iron implements.

Yellow ochre is a clay found locally and white paint (*bakun*) is a chalky substance also found locally; neither requires special processing. Black paint (*amsaling*) is obtained by mixing soot from the underside of roofs with water or saliva; soot from a men's house is preferable because of its sacredness. The design in relief is always painted black and other parts of the design are painted according to the inspiration of the artisan.

Houseboards may occasionally have a hole bored on each side of the top of the entrance hole to facilitate fastening of the board to the front of the house but most boards are simply bound at the top with cane and kept in place with a horizontal batten fastened across the board just above the entrance hole. A few are held in place at the bottom by a forked stake which cradles the bottom of

18. Telefolmin man binding a *mok* stone adze blade on to a haft (1964).

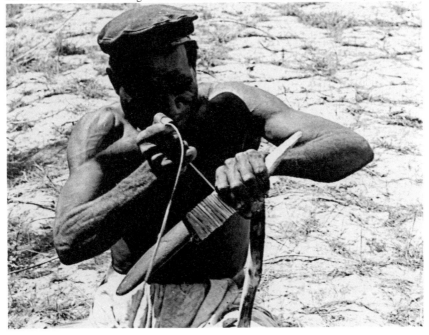

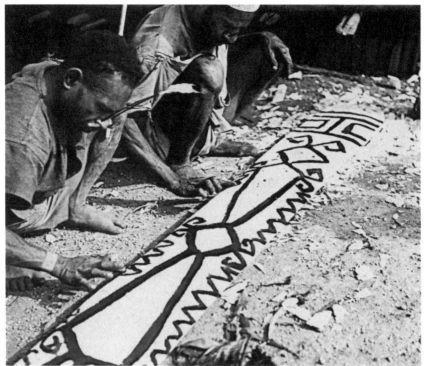

19. Marking out the design on a new houseboard with black pigment; Bulolengabip village, Tifalmin (1964). (Copyright: Museum of Mankind.)

the board whereas most just rest on some part of the floor timbers.

Shields have four holes bored (two at the top and two at the bottom), varying in position from quite close to the edges of the board to almost at the centre. Two pieces of cane are knotted at their ends and pulled through the top two holes, from front to rear, twisted around one another several times and then pulled back through the two holes at the bottom from the rear to the front. They are then knotted and trimmed.

Artisans and owners

Houseboards and shields are made exclusively by males but the age of the artisan does not appear to be significant. Not every man in the community is sufficiently talented or sufficiently motivated to make a houseboard or a shield and even fewer are talented in the execution of the designs. There is, then, a

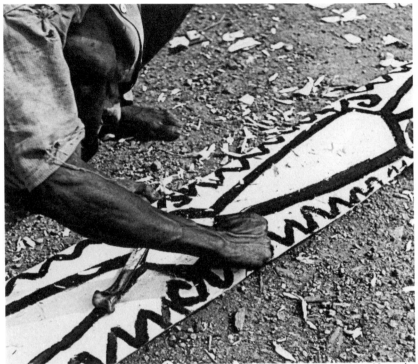

20. Carving relief on a houseboard; Bulolengabip village, Tifalmin, 1964. Note the cassowary-femur gouge. (Copyright: Museum of Mankind.)

tendency towards specialisation. Should any person other than the owner, joint owner, or a very close relative, take part in the manufacture of a houseboard or shield, ideally he must be paid. Payment is normally in the form of food to sustain the artisan during manufacture, or a gift of pork after completion. This gift is almost certain if the owner is of *kamokim* ('big-man') status or aspiring to such status.

An examination of the kinship relationship of those who assisted in the manufacture of houseboards revealed that: there were no cases where a senior relative assisted (in terms of kinship, not necessarily age); affinal relationships (through marriage) and cognatic relationships (by blood) were of equal significance; the Telefolmin say 'one's brother-in-law is as one's brother' and together these account for half the relationships activated for the manufacture of houseboards.

Though two or three men may have families living in the one

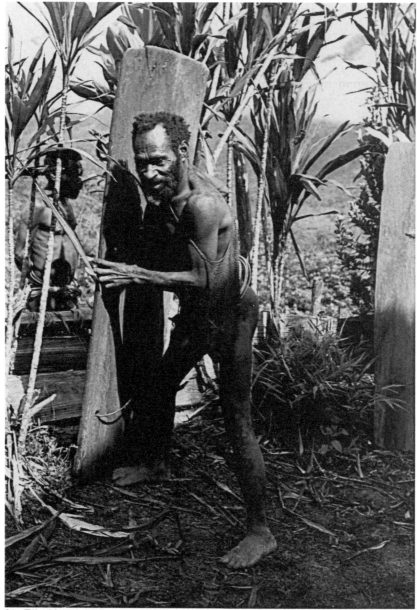

21. Elip Valley man demonstrating defensive use of shield (1967).

house and own it jointly by virtue of having cooperated in its construction, they do not automatically become joint owners of the houseboard attached to that house. Only if they have inherited it jointly, jointly manufactured it or jointly commissioned its manufacture, can they be considered joint owners.

A woman may become owner of a houseboard by gift or by inheritance. The board is regarded as hers and although she may allow her husband or brother to assume ownership and right of disposal, this is only by grace and at any time she could assert full rights of ownership. This is true also of ownership of shell-wealth and pigs.

Inheritance of a houseboard is determined by the fact that the houseboard remains on the house of the deceased and is inherited by the senior occupant; this is usually, but not necessarily, a son. But he is seldom the eldest, for the eldest has usually established an independent household before his father's death.

It seems that houseboards and warshields have a maximum lifespan of about one hundred years. Houseboards are continuously exposed to the weather and to deterioration by constant traffic in and out of the houses. Shields have a greater chance of survival, providing they are not damaged or lost in warfare, because they are kept in the smoky interiors of men's houses, away from the weather. The accumulation of generations of soot renders them relatively immune to attack by borers and fungi.

The use of shields

The Mountain-Ok shield was normally carried by an unarmed shield-bearer, a man of exceptional courage. He carried a stick with which to sweep off arrows that became embedded in the front of the shield. This man often acted as a scout on raiding trips, returning to collect his shield for the attack. He would advance accompanied by one or more bowmen who sheltered behind the cover of the shield. Cranstone (1968) says: 'The shield-bearer controlled the tactics of his group, since where he went, the archers had to go; his was therefore the post of responsibility and honour.'

Of necessity, then, the shield was light. The average weight of nine shields Cranstone collected for the Museum of Mankind was 6.4 kg (14 pounds).

The shield could also be used as a weapon to batter and pin down an enemy until the bowmen could fire arrows at the victim. In demonstrations of the shield being used, the bearer held it at either edge, away from his body, and ran with it, moving it

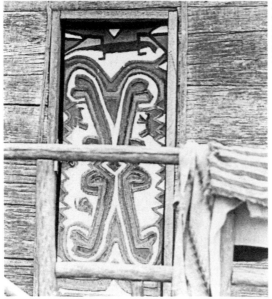

22. Nowadays, shields may be carved for sale to foreigners and sometimes hung on hinges as doors for non-traditional style houses (Elip Valley, 1972).

slightly from side to side. The bowmen followed in single file, shooting arrows as they went. However, these demonstrations were always light-hearted affairs and may have been more in the nature of public dances than real demonstrations!

The Telefolmin often took their shields with them when going to gardens in territory adjoining enemy lands; thus they also had defensive purposes (figure 21). They were used to fight other tribal groups but rarely against other parishes within the same tribe. Nowadays, shields are only made for sale or are occasionally hung on hinges as doors to non-traditional forms of housing (figure 22).

Design types

For both houseboards and shields, but not usually for the narrow carved and painted boards either side of the main houseboard making up a decorative facade, it is possible to isolate a centrally placed motif surrounded by minor, bordering design elements. The designs bear little visual resemblance to any natural phenomena, animate or inanimate; they appear to be non-representational and are geometric in character. Sometimes the figure appears to be indicated by the black lines in relief; in other cases the black lines in relief define the boundary between

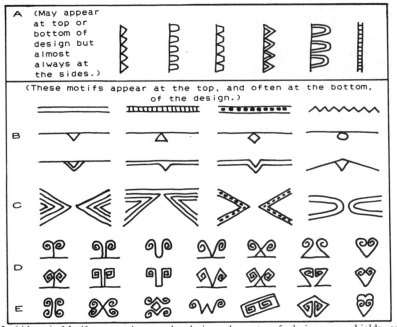

23. (Above) Motifs appearing as bordering elements of designs on shields and houseboards.
24. (Below) Three major design types for shields and houseboards, and their variants.

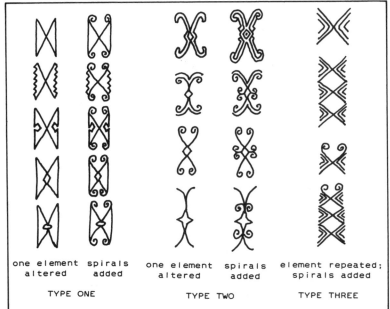

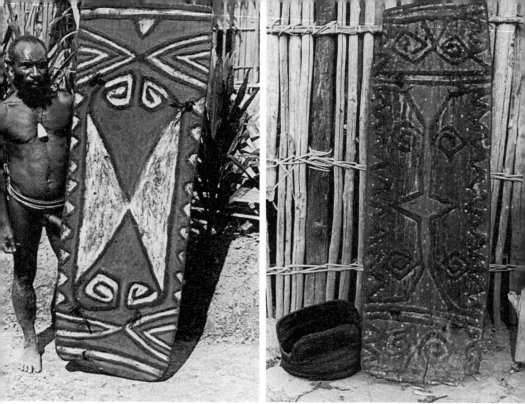

25. (Left) Shield of Derolengdam, Telefolmin (1967).
26. (Right) Shield of Elip Valley, Telefolmin (1967). Note the body armour at left.

figure and ground. The most striking structural feature of the designs is their symmetry. They are almost always completely symmetrical around the vertical axis, with only minor infringements of symmetry around the horizontal axis.

The range of designs at first appears overwhelming but careful analysis reduces this range to combinations of three central motifs and their variations and five bordering design elements. The central motifs vary independently of the design elements surrounding them. Almost always the design element on either side of the central motif is a zigzag. At top and bottom there may be a pair of parallel lines, sometimes the inner line protruding at an angle towards the central motif or bearing a triangle in the same position. Above the lines at the top of the design, a pair of spirals may be found. The five categories of bordering design elements (figure 23) are the same for both houseboards and shields. The top of the houseboard design is likely to be a little more complex than the bottom. The bordering elements on shield designs are

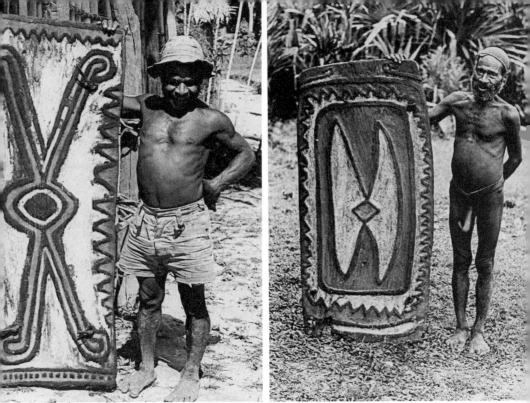

27. (Left) Om River (Dulanmin) shield, captured by the Telefolmin (1967).
28. (Right) Shield of Magalsimbip, Wopkeimin (1972), now on display in the Papua New Guinea National Museum.

usually identical at top and bottom so that it would be difficult to determine which is the top and which is the bottom of a shield.

Houseboard designs

Analysis of the central motifs on houseboards revealed three major types (figure 24): I, two horizontally opposed triangles (figures 25, 28 and 29); II, a central rhomb or circle with diagonals from the centre to the four corners (figures 26 and 27); III, one or more paired sets of nesting chevrons (figure 3, left).

It was found that, starting with these basic designs and adding a maximum of only two more design elements, of a total sample of 220 houseboards, 87 were attributable to the first design type, 64 to the second and 44 to the third, making 195 in all. Thus only 25 designs remained unclassified.

The date of manufacture of most of these boards was obtained by reference to the various historical events recounted earlier and by comparing to the birth year of persons whose age could be

estimated within a few years. In this way, 171 boards could be allocated with reasonable accuracy to eight time periods and of these 161 belonged to one of the three major design types. Table 1 shows the results of an analysis of design type by estimated time of manufacture.

Table 1. Design types on houseboards by period of manufacture.

Design type	pre-1900	1900-13	1914-26	1927-36	1937-43	1944-53	1954-61	1962-7	Total
I	—	6	4	7	8	31	12	9	77
II	6	6	—	—	—	7	8	30	57
III	1	15	5	2	—	2	2	—	27
Total	7	27	9	9	8	40	22	39	161

From this it is apparent that there has been a rise and fall in the popularity of the design types. Designs of type III were the most popular at the beginning of the twentieth century; designs of type I reached a peak of popularity between 1944 and 1953, giving way to the increasing popularity of type II in the early 1960s. There is also the suggestion that designs of type II may have been popular some time before 1900. However, few have survived to be recorded.

These results in no way imply that designs of one type have developed from designs of another. Within each of the three types there are a number of possible variations, some perhaps as yet unrealised, and only one or two variations may be favoured at any particular time. The design favoured may be one of the stock of variations within the type or a new development from one such variation but not necessarily a development from the previously favoured type.

Newton (1961) had already suggested this for Papuan Gulf objects: 'When . . . an object is statistically rare, this may rather suggest the historical increase or decrease of that object's popularity in an area: a process familiar enough to us by the name of "fashion".'

An examination of the geographic distribution of the 195 houseboards of design types I to III is also interesting. Table 2 shows that type I was most popular among the Telefolmin of Eliptaman; that type II was most popular among the Telefolmin of Ifitaman; and that type III was most popular among the Falamin, although a considerable number of that type were also to be found among the Telefolmin of Ifitaman and five of the total of eight Ulapmin houseboards were also of that type.

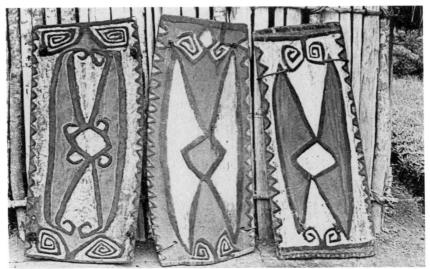

29. Two shields of the Ulapmin (right and centre) and one of the Tifalmin (left) (1964). All were collected by B. A. L. Cranstone and are now in the Museum of Mankind in London.

Table 2. Distribution of design types on houseboards by area.

Design type	Ifitaman Telefolmin	Eliptaman Telefolmin	Falamin	Ulapmin	Total
I	21	56	10	—	87
II	51	9	4	—	64
III	14	7	18	5	44
Total	86	72	32	5	195

Warshield designs

Utilising the same three design types as developed for the houseboards, it was found that, of a total of 120 shields, 25 shield designs were of type I, seventy of type II and seventeen of type III, leaving eight of other designs. Four of these latter were unique to the Wopkeimin.

Facade designs

Decorative facades (*am-fut*) are attached to men's cult houses among the Faiwol-speaking Angkeiakmin and Fegolmin, the Tifal-speaking Wopkeimin (figure 8) and Tifalmin (figure 30), and the Oksapmin. One made by a Fegolmin man existed among the Falamin and one among the Telefolmin of Ifitaman, a copy of the Tifalmin example. These facades may consist of a central houseboard with several narrower carved and painted boards

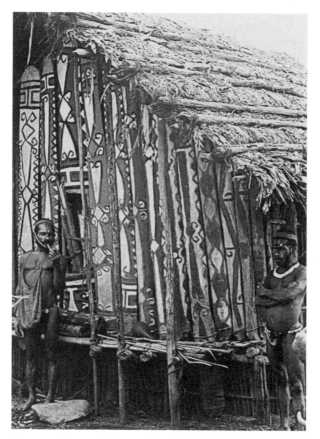

30. The cult house at Bulolengabip, Tifalmin (1964). B. A. L. Cranstone collected four boards from this facade, two for the Museum of Mankind and two for the Papua New Guinea National Museum. All were replaced (one of which is on the far left) unpainted. In 1965, the entire facade was purchased for the Musée des Arts Africains et Océaniens in Paris and was never replaced.

fastened on either side, or of the narrower boards only. In the case of the Wopkeimin spirit-house at Bultemabip, there is a panel of carved and painted boards on the outside rear wall (figure 8) as well as the houseboard and flanking narrow boards on the front wall.

The designs on fourteen houseboards that are part of the facades can be allocated as follows: four of type II (one Wopkeimin, two Tifalmin and one Oksapmin); three of type III (all Angkeiakmin); and seven of a fourth design type (figure 2) with a central motif interpreted as strings of Job's tears (*Coix lacryma*) (three Angkeiakmin and four Fegolmin).

5
Other decorated objects

Arrows

The bow and arrow is the principal hunting tool and weapon of the Mountain-Ok: unlike many other groups in New Guinea they do not have spears. Other weapons used are clubs of the stone-headed and the spatulate palmwood types. Although the palmwood clubs usually have a simple incised and painted design on one side (designs related to those on arrows) there are none on the stone-headed clubs. A wealth of design, however, is lavished on arrows.

Arrows (*un*) are generally around 1.5 metres (5 feet) long and have neither nocks nor feathers. They may consist of two or three sections: the light reed shaft (made from *Miscanthus floridulus*, related to bamboo) and a hardwood or palmwood point; or the shaft, a foreshaft made of palmwood and a bamboo blade (figure 31). The point is socketed into the end of the shaft and bound with string made from bark fibres or with finely split lengths of bamboo or cane. The foreshaft is attached to the shaft in the same manner but the bamboo blade is attached to the distal end of the foreshaft by binding the foreshaft into the concave end of the bamboo blade, or the bamboo blade is socketed into a split in the distal end of the foreshaft. All joins are tightly bound and may be glued with a tree sap. Some arrows have composite heads with several prongs for shooting birds and lizards. Others have a blunt knot of wood to stun or kill lizards and birds where the skin or pelt is sought undamaged. Sometimes a cassowary claw or sharp piece of bone may be slipped over the hardwood point of a two-piece fight arrow; it is designed to detach in the victim's body.

The hardwood or palmwood points may be plain or intricately barbed, often with graphic designs chiselled in two or more bands with barbs or notches between. The cross-section of the points may be circular, triangular, square or lenticular. The palmwood foreshaft between shaft and bamboo blade is circular in cross-section and is often chiselled with designs painted in red and white. Barbs and hooks may be cut into the bamboo blade and a row of cane thorns fastened down the centre of the blade which is designed to break off in the victim and make death more likely.

The Mountain-Ok name their arrows by reference to their

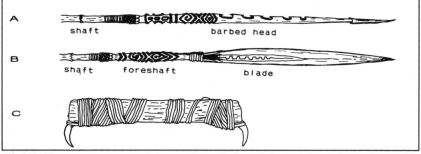

31. (A) Two-part arrow used in warfare: shaft and barbed head (sometimes with detachable bone point); (B) three-part arrow used in warfare: shaft, foreshaft and broad bamboo blade; (C) rat's incisor carving tool (not to same scale as arrows).

particular function, the arrangement of barbs and the type of wood of which the arrowhead is made.

Most of the arrows decorated with graphic designs are those used for hunting wild pigs and cassowaries or for fighting. Arrows used for hunting small game are at best decorated with the most elementary designs.

The designs are chiselled out of the wood using a rat's incisor tool (figure 31). This is one side of the lower jaw of the animal bound to each end of an 8 to 12 cm (3 to 5 inch) handle. The chiselled-out areas of the arrow are often filled with white chalk and red ochre; the raised lines of the design are the black of the palmwood from which the piece is carved or the natural hardwood colour.

The bamboo blades may also carry incised designs in the concave surface and a tuft of pig hair may also be bound into the blade at that point. A wisp of bird-of-paradise (*Raggiana*) feather may be tied to fight arrows where point is joined to shaft.

The black palmwood bows (*unuk*) are usually about 1.8 metres (6 feet) long and have a bowstring of split cane. They are not carved but sometimes wisps of *Raggiana* plumage or red parrot feathers are attached at the top end. Black palm is a lowland material so it is not surprising that some significant cultural contacts exist along trade routes between lowlands and highlands and that arrows are frequently traded as well as bows.

The universal presence in New Guinea of arrows specifically for use in warfare suggests that all groups experienced armed conflict fairly regularly, though probably with only modest loss of life. Warfare was also instrumental in the movement of artefacts

from one area to another. Tales of fights mention artefacts such as shell valuables, stone tools, shields and arrows being picked up and carried off or deliberately stolen from a body or a routed settlement.

Arrows could be made by anyone but the more complex arrows and the more elaborate designs tended to be made by specialists, simply those with a predilection for acquiring the skill. Such arrows could be commissioned or obtained through trade. Designs tended to be copied from arrows already existing within the group but could also be copied from arrows traded or stolen from other groups. Thus the Telefolmin consistently recognised one particular design (figure 32) as Mianmin in origin.

The best way to record designs found on arrows is to do a rubbing with a lumber crayon. This transfers the three-dimensional carving to a two-dimensional form, making it much easier to 'read'. A piece of paper is wrapped once around the part of the arrow bearing the design and, as the paper and arrow are

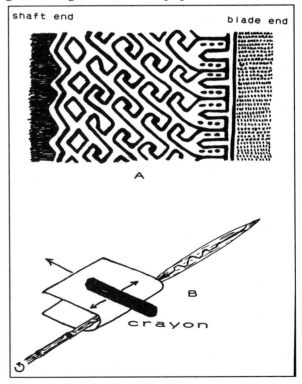

32. Rubbing of arrow design and method of obtaining rubbing.

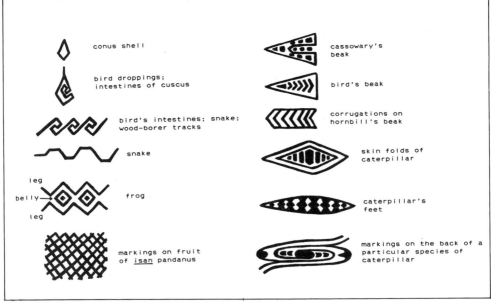

33. Some common arrow design motifs and their meanings.

rolled, the crayon is rubbed back and forth over the design. This may be continued to the limit of the paper, thus repeating the carved section over and over (figure 32). Information on each arrow may then be added to the sheet of paper, such as a sketch of the form of the arrow, its vernacular name, its particular use, information on the meaning of the design elements, the names of the arrowmaker and the present owner, the village of both and so on. This obviates the need to collect all the arrows in an area in pursuit of a large sample. Then an analysis of morphology and designs can be done by provenance and language group.

A rather laborious but effective method of classifying designs is firstly to go through the entire sample placing together all designs that are alike. 'Alike' can be interpreted in various ways but, for the first sorting, it should be interpreted quite strictly. A second sorting will group designs that differ only in one respect, say, by having repetition, or a logical permutation of a particular design element. Continuation of the process will yield sets of clearly related designs, although these may have nothing much to do with the way the arrow designers themselves consciously analyse the range of designs. Their names for designs or elements of the

designs refer to the phenomena of the natural world, in particular the natural world of the hunter. As for houseboard and shield designs, a particular design element or motif may be given different meanings by different informants (figure 33).

However, the analysis of the designs according to a system of logic apparently independent of the logic of the designers themselves has its uses: it enables the analyser to compare designs across cultural and linguistic boundaries. Although the full range of arrow design elements and their distribution cannot be covered here it is possible to discuss the structural principles involved.

There are five structural principles (figure 34), apart from the rendering of a single element such as a line or zigzag. These are:

serial repetition: the repetition of a design element or motif from one end of the design to the other, whether in-line or interlocking;

inversion symmetry or 'mirror image': bilateral symmetry around the 'horizontal' axis of the design (at right angles to the length of the arrow);

diagonally deflected symmetry: a special case of inversion symmetry where the mirror image is deflected to one side so that an interpenetrating design is formed;

agglutination: the building of a design through the addition of differing and/or alternating motifs along the axis of the length of the arrow;

single asymmetric motifs: a line of linked spirals, for example.

A total of 729 arrow designs from the Mountain-Ok area were included in an analysis of the structural principles of design; the results are set out in Table 3.

34. Five major structural principles of designs carved on arrows: (A) serial repetition; (B) inversion symmetry; (C) diagonally deflected symmetry; (D) agglutination; (E) single asymmetric motifs.

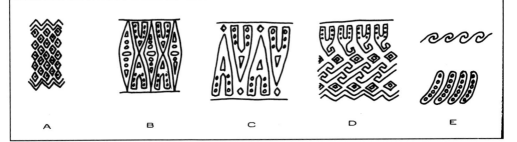

Table 3. Structural principles of arrow designs of the Mountain-Ok.

Language group	N	SR %	IS %	DD %	AG %	SA %	Total %
Faiwol	85	3	24	34	19	20	100
Tifal	106	2	27	30	29	12	100
Telefol	263	2	22	27	35	14	100
Oksapmin etc	29	3	7	35	41	14	100
Mianmin	246	2	18	8	61	11	100
Total	729	2	21	22	41	14	100

SR: serial repetition; IS: inversion symmetry; DD: diagonally deflected symmetry; AG: agglutination; SA: single asymmetric motifs; N: number.

The corpus of designs from Oksapmin and the other Om (Strickland) River groups (the Dulanmin and Sugamin) differ significantly from the corpus of designs from the other language groups in having a low percentage structured on the principle of inversion symmetry; the Mianmin designs differ in having a much lower percentage structured on the principle of diagonally deflected symmetry. A gradient of percentages of designs structured on the principle of agglutination exists from south to north: the Faiwol in the south at 19 per cent, the Tifal, Telefol and Oksapmin in the central area at 29 per cent, 35 per cent and 41 per cent respectively, and the Mianmin in the north at 61 per cent. There is a trend in the opposite direction for single asymmetric designs (from 11 per cent of Mianmin designs to 20 per cent of Faiwol designs) and perhaps a tendency for a trend from west to east in the designs structured according to inversion symmetry (27 per cent of Tifal designs in the west to 7 per cent of Oksapmin and related designs in the east).

This type of analysis has the same limitations as the examination of houseboard designs. At any particular period of time the popularity of certain designs with particular structural principles could be different in each area and the balance and trends could change.

The arrows used in this analysis were not necessarily a representative sample of what existed at the time and no doubt some were very old arrows and others were made much more recently. It will never now be possible to date the arrows in the same way that the houseboards and shields were dated. Also, many groups were unrepresented (Bimin-Kuskusmin, Baktaman-min, Seltamanmin, Wopkeimin, Atbalmin and the Irian Jayan groups) whilst the number from the Oksapmin and Om River groups were small. Nevertheless, the preliminary analysis suggests that the structural principles as analysed are useful in

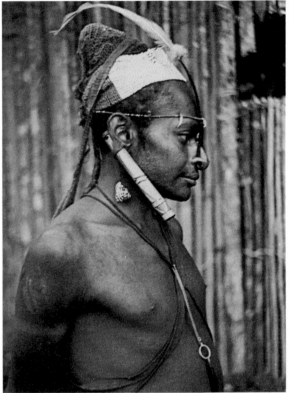

35. Atbalmin man wearing a *teruntet* (paint container) through his earlobe (1965).

distinguishing the design characteristics among the various groups.

Bamboo smoking tubes and paint containers

Throughout the eastern section of the Mountain-Ok areas (not in Irian Jaya), bamboo smoking tubes (*suget*) are used for tobacco (*suk*). These are open at both ends, average 200 mm long by 12 mm diameter (8 inches by half an inch diameter) and are decorated with incised or etched designs using the rat's tooth tool. The tobacco is rolled in a leaf and the resulting 'cigarette' is placed in the open end of the tube. Other smoking devices are used in some areas, such as a small gourd used by the Tifalmin. Faiwol and Tifal speakers also use a short, curved length of hollow branch. Neither of these alternative apparatus is decorated in any way.

The paint container (*teruntet*) is a short length of bamboo cut

36. Bamboo eartube/paint container and two rubbings. Note the consistency of the designs.

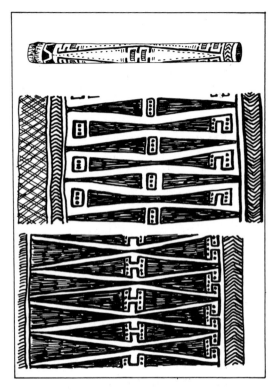

with the node intact at one end and the other end open. The paint is the red powder used for face-painting and is kept in the tube by a plug of barkcloth. The tube is shorter and thicker than those used for smoking, averaging about 150 mm long by 20 mm diameter (6 inches by less than an inch diameter). Paint containers are worn through a hole in the earlobe by either men or women (figure 35), though they are not common.

The designs incised on the paint containers are of one type (figure 36) and different from those on the smoking tubes. However, the designs on both objects are closely related to certain arrow designs. Since the existence of decorated arrows no doubt predates the introduction of tobacco into New Guinea from America via South-east Asia three or four centuries ago, it is not surprising that the Mountain-Ok would look to their arrows for smoking tube designs. But why did they not use a similar variety of designs on their paint containers? Perhaps to distinguish the two artefacts from each other.

Hand-drums

Not all Mountain-Ok groups make the hourglass-shaped hand-drums (*ot/wos*); some import them from those who specialise in their manufacture. For example, although a few Telefolmin make their own drums, most are imported from the Atbalmin to the west. Nevertheless, the design is the same throughout the area: it is approximately 1 metre (3 feet) in length and between 100 mm and 150 mm (4 to 6 inches) in diameter at each end, narrower at the waist, and with a carved and painted design, always the same, at the distal end (figure 9). Occasionally a Lowland-Ok drum may be traded from the south; these may have a plainer design at the distal end with the 'fish-mouth' opening common for Papuan Gulf and Papuan Plateau drums.

During the hollowing-out process, when the breakthrough is achieved in the middle of the drum, the Telefolmin say a spell. The carver says: 'I have opened up your throat; so you must faithfully copy the voice of the bird *kabel* and of the bird *ung-ang-im.*' The *kabel* cries: 'dou, dou, dou, dou' and the *ung-ang-im* cries 'ung-ang-a, ung-ang-a, ung-ang-a, ung-ang-a'. These two sounds represent the sound of the drum and, when it is being tuned, people will comment on its tone — its purity of *kabel* or *ung-ang-im* — or the balance of the two sounds.

The tympanum is formed from the skin of a lizard stretched tightly over the proximal end of the drum and glued into place with the sap of a tree. Small lumps of beeswax are pressed on to the skin to improve its tone. At the distal end, a design is carved and painted with red, white and black paint. The design is identical for all the Mountain-Ok groups but the meanings of the design elements may vary. The Telefolmin provide meanings identical to similar motifs on houseboards and shields.

The Wopkeimin story of the origin of the drum was reported by Roberts (1986):

'A woman, deep in the rain forest, heard a vibrant sound. She paused from gathering sago as the sound reached her ears, soon abandoning her work altogether to walk further into the jungle in search of the sound.

'She came upon a tree called "wos". Its trunk throbbed and pulsed resonantly before her, giving off a rich, percussive ring. Enthralled, she removed her skirt and wrapped it around the trunk of the tree.

'The woman returned to her village and reported the story of the tree to her husband. Together they went back and found the tree, her skirts marking the place. The husband cut down and

37. (A) Taro knife/scraper (*yom*); (B) designs incised on taro knives/scrapers; (C) taro stalk severed from corm and leaves removed, ready for use as planting stock; note similarity to motif of design to right; (D) three designs carved on palmwood clubs (*bial-sanam*).

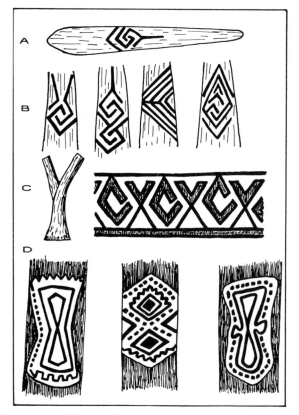

hollowed the tree; then, stretching a lizard skin over one end, he created the first drum. Drums today are still called "wos", making the same sound as the tree long ago.'

Taro knives and palmwood clubs

Taro knives *(yom)* are flat, paddle-shaped pieces of bamboo 150 to 200 mm (6 to 8 inches) long, used to scrape the burnt skin from cooked taro and to cut cooked taro corms into slivers which are then pulverised by hand into a sort of dough; the oily juice of cooked red pandanus fruit is then poured on top as a sauce. The taro knives are usually decorated by incising a simple design on to the external skin of the bamboo with a rat's incisor tool. The designs are most often of interlocking, rectilinear spiral forms found also on arrows; some are related to the hand-drum designs and probably represent the taro itself (figure 37 A-C).

Palmwood clubs *(bial-sanam)* are about 1.5 metres (5 feet) long, of slender spatulate shape and feature a small design, carved in the same way as shield, houseboard and drum designs are carved, about midway along one surface. The most common design is roughly of hourglass shape (figure 37 D) and is said to represent a frog; it is structurally similar to one of the arrow designs and to the design etched on the bamboo paint containers/earlobe tubes.

Paintings on bark and rock surfaces
The Mountain-Ok occasionally paint crude figures on the bark surfaces of the internal wall linings of their houses and on the walls of rock shelters (figure 38). These appear to represent lizards and male and female human figures but seem to be a form of graffiti with no ritual significance. The pigments used are the usual black, white or red.

38. Painting of lizard: charcoal on wall of rock shelter, Kauwol valley (1965). The ruler is 12 inches (30 cm) long.

6
Symbolic significance and function of art and decoration

Meaning of colour

The colours used to paint designs on shields, houseboards, arrows and hand-drums were said by the Telefolmin to have no particular significance but, according to Barth (1975), who carried out in-depth research among the Faiwol-speaking Bakta-manmin: 'red is clearly an idiom for descent and the ancestors, black indicates male solidarity and seniority and white stands for food, prosperity and plenty.'

Red is used on the initiands' faces and smeared on ancestral bones and on the domestic pig jawbones of the relic and trophy arrays; it is said to impart 'heat' (that is, power) to the bones. It is possible that the redness of blood is at least one aspect of the significance of this colour.

Black is the colour of the soot that accumulates on the underside of the roofs of the men's houses, thus representing the solidarity of the men's association, both in social and ritual terms. It is also the colour of the boar's bristles and the cassowary's plumage, representing male aggression.

White is the colour of the taro corm when the skin is removed, of pig fat, of mother's milk and of the shells which form trade valuables and bride wealth.

Meanings of designs on houseboards and shields

The Telefolmin, when asked to give a meaning for the entire design on a houseboard or shield, deny that there is one. However, they do provide meanings for particular elements of the total design. Despite the variety of meanings attributed to each design element and the apparent lack of consistency in these meanings, a pattern emerges.

Central lozenges and circles frequently represent the vagina, the abdomen of humans or spiders, the liver, the solar plexus, the heart, the navel or the stomach. Diagonal extensions with spirals at the extremities are limbs of humans, spiders, crocodiles or lizards. Pairs of spirals at the top of the design are frequently interpreted as eyes of lizards or humans or birds. The counter-posed triangles of the type II design are most often wings of the flying fox. Various other body parts of humans, animals and birds

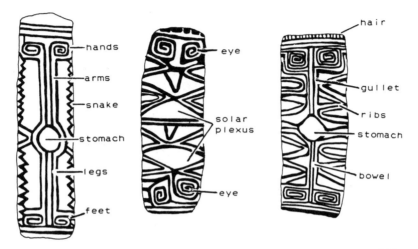

39. Anthropomorphic interpretations of design elements on Angkeiakmin shields.

feature in the appropriate positions of the design. It would then appear that there is an underlying structure which is a metaphor for the human being, that is, for the ancestors. In the case of some designs this is most explicit (figure 39).

The Mountain-Ok give their shields names and attribute animistic characteristics to them. The Telefolmin say their shields quiver in anticipation of the fray; that they become light during attack and thus easy to handle; that they swell around the tips of penetrating arrows to prevent them causing harm to the shield-bearer. The Fegolmin and Angkeiakmin initiate their shields by firing arrows into them after they have been made so that they will not be afraid when carried into a fight: a frightened shield might shake violently and become impossible to hold!

The interpretation of the design elements is often anthropomorphic, or metaphorically so; this is often explicit among the Faiwol-speaking Angkeiakmin and Fegolmin. Their shields are kept in the cult house with ancestral skulls placed on the floor in front of them and small ancestral relics (fingerbones, vertebrae and the like) may be kept in small string bags *(menamem)* and hung on the top end of the shields (figure 40). The shields are said to 'keep the skulls warm' and heat is power. The small *menamem* devoted to warfare are taken into the fight along with the shields. The bearer of the shield and *menamem* is not permitted to walk

through water: he is carried because the cold of the water could neutralise the heat of the relics' power. Thus the shields may be thought of as representations of the ancestors and/or their power, although this is not explicitly stated.

The houseboards also appear to be part of this cluster of associations. Those of the Telefolmin and their neighbours, the Falamin and Ulapmin, may be attached to cult houses, men's club houses or to women's houses. Among the Angkeiakmin, Fegolmin and Wopkeimin, they appear alone, or as part of a decorative facade, on cult houses or men's club houses, but never on women's houses. Among other groups to the east and west (Tifalmin, Oksapmin), carved and painted boards may be attached only to the major cult houses and never to ordinary men's houses or to women's houses.

It is interesting that the Telefolmin, Falamin and Ulapmin keep ancestral relics (skulls, thighbones, and so on) in cult houses, men's club houses and in women's houses (figure 11); the Angkeiakmin, Fegolmin and Wopkeimin keep such relics only in the cult houses and men's club houses, never in women's houses (figure 16); the Tifalmin and Oksapmin keep such relics only in the major cult houses or in caves nearby because they believe that the relics of the ancestors are so powerful that storing them anywhere in the village could bring sickness to all (figure 41).

The Telefolmin, Falamin and Ulapmin deny any significance for houseboards other than that of decoration. The Angkeiakmin, Fegolmin and Wopkeimin state that the house decorations promote the well-being of the taro crop. The Angkeiakmin say that the people south of them (the Awin) have no house decorations 'because they have no enemies'.

The weight of evidence suggests that, despite the disinterest of the Telefolmin, Falamin and Ulapmin in verbalising the significance of the houseboards, such house decorations are in a sense representations of the power of the ancestors whose relics are preserved inside the house so decorated. This power is necessary for the well-being of the taro crop and for the preservation of life and territory. The boards are thus the visible sign of the power that emanates from the bones and other relics kept inside. They serve to maintain a feeling of security among members of the village and to warn outsiders of the forces with which they have to deal. However, this communication does not take place at a conscious, verbal level.

Why should there be these differences in the geographical distribution of ancestral relics and associated houseboards for the

40. (Right) Ancestral skulls and thighbones on the floor of the cult house at the Angkeiakmin village of Bolobip (1967). They are placed in front of the shields, which 'keep the skulls warm'. Note the *menamem* (small feathered string bag) hanging from the top of the shield at left; the shield at right has almost completely deteriorated. Domestic pig jawbones at upper right.

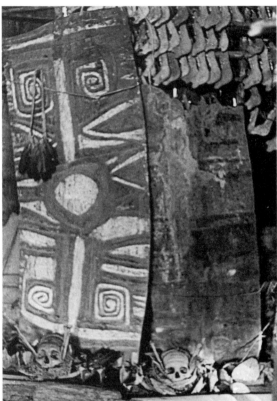

41. (Below) Skulls and other human bones in cave, Tifalmin (1964).

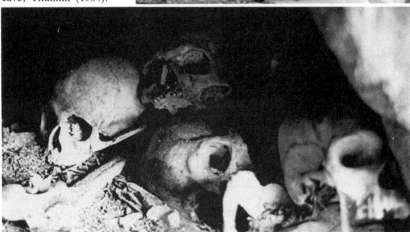

three categories of houses? The answer is to be sought by reference to ecological factors. The Telefol-speaking Telefolmin, Falamin and Ulapmin are situated at what appears to be the oldest centre of settlement in this part of New Guinea and they have used up certain of their natural resources, particularly hunting resources. As hunting provided a significant part of the protein requirement for these people, something had to take its place. This seems to have been achieved by an elaboration of pig husbandry. The Telefolmin plant large gardens of sweet potato specifically to feed their pigs. They also breed and keep male pigs to sire offspring to their sows whereas their Faiwol- and Tifal-speaking neighbours (the Angkeiakmin, Fegolmin, Wopkeimin and Atbalmin) rely upon wild pigs to do this.

However, it is the women who nurture and protect the pigs, who cry when they are slaughtered and who become renowned as skilled pig husbanders. The skulls of such women may be preserved and invoked, even by women, among the Telefolmin, Falamin and Ulapmin (figure 42), but not among the other groups. Thus, the increased responsibility of women for providing protein is acknowledged by allowing them a degree of access to the cult of the ancestors. This is further acknowledged by permitting relics to be kept in the women's houses and carved and painted boards to be attached to them.

Meanings of designs on, and significance of, hand-drums

Roberts's research among the Wopkeimin establishes that there is an intimate connection between drums and taro:

'At the annual "selban" [equivalent to the Telefolmin *mafumban*] all participating men go to sacred gardens near Bultem and gather the largest taro roots. Singing a melody special for the occasion which has no words, they charge, in step, uphill to the centre of the village. There they rush into the main cult house, each gripping a taro root in the middle with one hand, beating the cut end as if it were a drum.

'After increasingly frenzied incantations by the cult leader, one can hear a tremendous roar as the beating of taro changes suddenly to the beating of drums. The roar shakes the cult house as, two by two, the men rush back out with their drums, taro symbols carved in relief at the base . . . Joined by the women, the initiates thunder their drums through all phases of the "selban", including a night of dancing, without rest or water, until dawn.

'Drums are such potent factors in cult life that during the year they are kept "awem" [sacred/taboo], wrapped and hung high on

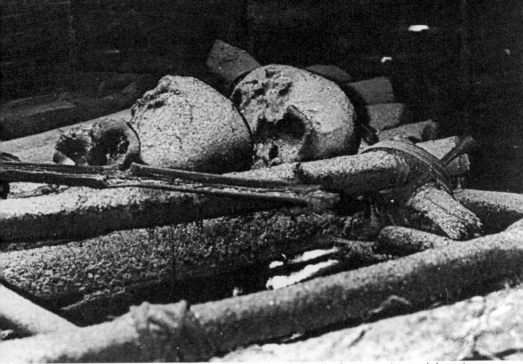

42. Women's skulls and eggshells on platform beside hearth of *unangam* (women's house) of the Falamin (1981). These are skulls of women admired for their pig-husbandry skills.

the smoky walls of the men's houses. They are not played out of the context of ceremony and never, under any circumstances, are they to be touched by the women.'

The decorative arts and maintenance of the cosmos

It has become clear that the designs on houseboards, shields and drums have intimate associations with the mystical religion and secret rituals of the Mountain-Ok. Their religion is an ancestor cult and they believe that the maintenance of the cult is essential to the success of all their endeavours: in hunting, fighting, gardening and pig husbandry. The designs on arrows and other objects apparently refer to the natural phenomena of the forest, the world of the hunter. However, it is highly likely that these are also metaphors of religious significance.

The Mountain-Ok see the cosmos as continually wearing out, moving towards chaos (Jorgensen 1981); it is only the perpetuation of the cult that balances this tendency and maintains order in the face of chaos. The designs with which the Mountain-Ok decorate various objects are one way of reminding themselves, on a daily basis, of their part in maintaining the cosmic order.

7
Relationships with neighbouring styles of design

Houseboards appear to be unique to the Mountain-Ok of Papua New Guinea. However, shields, arrows and smoking tubes are common in most of the neighbouring groups. It is therefore possible to compare particular aspects of these three artefacts across language boundaries to identify characteristics that are shared and those that are peculiar to certain groups. This is a useful exercise in that it may assist museum curators to determine the provenance of material for which they have no data, an altogether too common occurrence.

43. Form and designs of shields, West Sepik area.

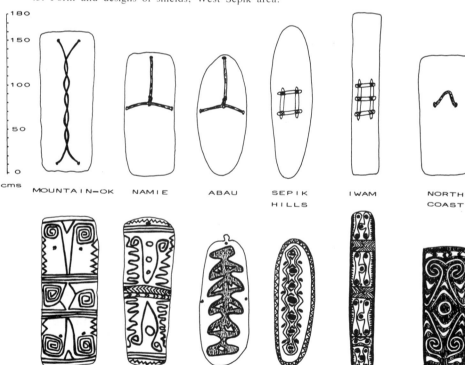

Shields

Shields can be compared as to both form and design (figure 43). The forms of shields, especially the types of carrying device, tend to be peculiar to particular areas. In general, shield designs are also quite specific to language groups except for the widespread Abau-Busa-Nagatman-Namie type of the Upper Sepik and the extraordinarily close similarity between many Namie and Mountain-Ok shield designs and between some North Coast and Namie shield designs.

Arrows

Arrows are widely consistent in form throughout the Mountain-Ok/Upper Sepik/Highlands area and several designs are very widespread, crossing several language boundaries (figure 44). This is not surprising given that arrows are easy to carry, to trade or to steal and may be picked up after battles.

Bamboo smoking tubes

The forms of smoking tubes, and many of the designs etched on to them, tend to be quite specific to language groups (figure 45) and this may be, at least in part, the consequence of the relatively short time since tobacco was introduced into Papua New Guinea. However, other designs are quite widespread (figure 46) and this may be because they are related to certain widespread arrow designs.

Conclusion

There is a style of design on shields, arrows and bamboo tubes of the Mountain-Ok that is characteristic of their culture. However, in the case of the arrows, even an expert could find difficulty in distinguishing certain arrows of the Mountain-Ok from certain of those of their neighbours. This is not surprising given the significance of the mechanisms of trade and warfare for the distribution of these items.

Certain shell valuables from the coastal areas north and south of the Highlands of New Guinea are traded over vast distances via many distinctly different language groups. Stone tools also have a wide circulation. For example, Mountain-Ok *fubi* adze blades, manufactured from stone quarried west of the Sibil Valley in Irian Jaya, were collected by D'Albertis on the Middle Fly River and in 1983 several examples were collected from Kambaramba near Angoram on the Lower Sepik.

Careful study of the full range of artefacts from specific regions will in due course yield an understanding of aspects of the history

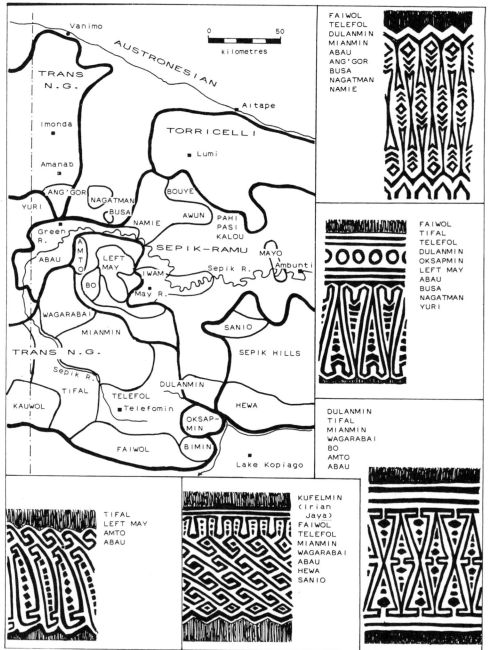

44. West Sepik language map with some arrow designs and their distribution indicated.

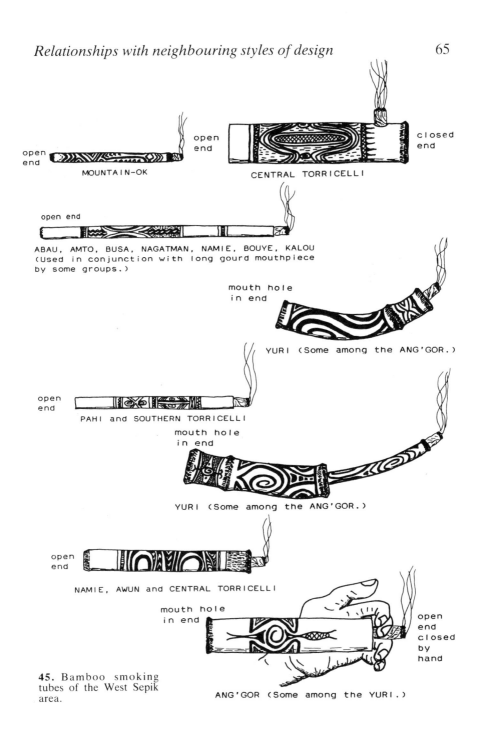

open
end

open
end
MOUNTAIN-OK

open
end

closed
end
CENTRAL TORRICELLI

open end
ABAU, AMTO, BUSA, NAGATMAN, NAMIE, BOUYE, KALOU
(Used in conjunction with long gourd mouthpiece
by some groups.)

mouth hole
in end
YURI (Some among the ANG'GOR.)

open
end
PAHI and SOUTHERN TORRICELLI

mouth hole
in end
YURI (Some among the ANG'GOR.)

open
end
NAMIE, AWUN and CENTRAL TORRICELLI

mouth hole
in end

open
end
closed
by
hand

45. Bamboo smoking
tubes of the West Sepik
area.

ANG'GOR (Some among the YURI.)

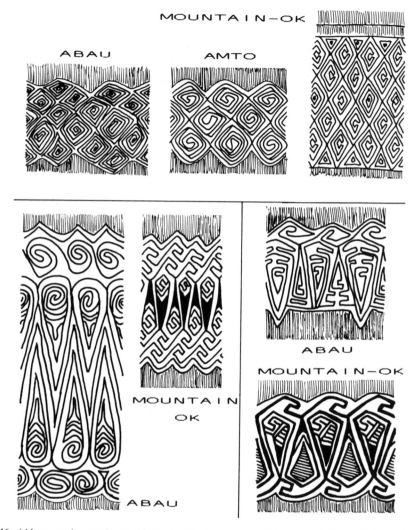

46. (Above and opposite page) Similarities between smoking tube designs of Mountain-Ok and other Upper Sepik groups.

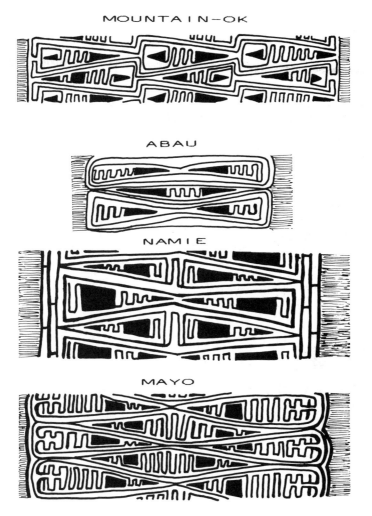

MOUNTAIN—OK

ABAU

NAMIE

MAYO

of the material culture and of the people of that region. The creative leap of the imagination may then be distinguishable from the conservative forces of tradition and the limitations imposed by the environment, leading to a deeper appreciation of the genius of humanity.

8
Further reading

Austen, L. 'The Tedi River District of Papua', *Geographical Journal*, volume 62 (1923), 335-49.

Barth, F. *Ritual and Knowledge among the Baktaman of New Guinea*. Yale University Press, New Haven, 1975. Only book available on Mountain-Ok ritual.

Brongersma, L. D., and Venema, G. F. *To the Mountains of the Stars*. Hodder and Stoughton, London, 1962. Lengthy account of Dutch expedition and photographs.

Campbell, S. 'The Country between the Headwaters of the Fly and Sepik Rivers', *Geographical Journal*, volume 92 (1938), 232-58.

Champion, I. *Across New Guinea from the Fly to the Sepik*. Lansdowne Press, Melbourne, 1966.

Craig, B. 'The Houseboards of the Telefomin Sub-district, New Guinea', *Man*, volume 2 (1967), 260-73.

Craig, B. *Houseboards and Warshields of the Mountain-Ok, Central New Guinea*. Unpublished Master's Thesis, University of Sydney (1969). Copies available at Fisher Library, University of Sydney; Museum of Mankind, London; and Robert Goldwater Library of the Metropolitan Museum of Art, New York.

Craig, B. *The Telefolmin*. Robert Brown, Bathurst, 1979, revised 1984. Basic text; colour photographs.

Craig, B. *The Star Mountains*. Robert Brown, Bathurst, 1984. Basic text; colour photographs.

Craig, B. 'Is the Mountain-Ok Culture a Sepik Culture?' in Lutkehaus, N., *et al.* (editors), *Sepik Heritage: Tradition and Change in Papua New Guinea*. Carolina Academic Press, 1987.

Craig, B. 'Relic and Trophy Arrays as Art among the Mountain-Ok, Central New Guinea' in Hanson, L. and A. (editors), *Art and Identity in Oceania*. Robert Brown, Bathurst, 1988.

Cranstone, B. A. L. 'Some Boards from a New Guinea *Haus Tambaran*', *Man*, volume 2 (1967), 274-7.

Cranstone, B. A. L. 'Warshields of the Telefomin Sub-district', *Man*, volume 3 (1968), 609-24.

Cranstone, B. A. L. *New Guinea: The Sepik Headwaters 1963-4*. The British Museum, 1966. Exhibition booklet; general information on Tifalmin.

Jorgensen, D. *Taro and Arrows: Order, Entropy and Religion among the Telefolmin*. Unpublished PhD thesis, University of British Columbia (1981).

Kienzle, W., and Campbell, S. 'Notes on the Natives of the Fly and Sepik Headwaters', *Oceania*, volume 8 (1938), 463-81.

Kooijman, S. 'Material Aspects of the Star Mountains Culture', *Nova Guinea*, volume 10, Anthropology 2 (1962), 15-44.

Newton, D. *Art Styles of the Papuan Gulf*. Museum of Primitive Art, New York, 1961.

Quinlaven, P. J. 'Afek of Telefomin . . .', *Oceania*, volume 25 (1954), 17-22.

Roberts, C. 'Wopkeimin Music and Song'. Unpublished manuscript (1986).

Schuster, M. 'In the Heart of New Guinea: the Eriptaman', *Sandoz Bulletin*, volume 14 (1969), 19-38. Brief account of Swiss expedition.

Thurnwald, R. 'Vorstösse nach dem Quellgebiet des Kaiserin-Augusta-Flusses, dem Sand-Fluss und dem Nord-Fluss bis an das Küstengeberge', *Mitteilungen aus den deutschen Schutzgebieten*, volume 29, number 2 (1916), 82-93.

9
Museums to visit

United Kingdom
Museum of Mankind, 6 Burlington Gardens, London W1X 2EX.
 Telephone: 01-437 2224 or 2228. Collections from Tifalmin,
 Ulapmin and Telefolmin by B. A. L. Cranstone, 1963-4.

Australia
The Australian Museum, 6-8 College Street, Sydney NSW 2000.
 S. Campbell collection from Upper Fly and Telefomin area,
 1936-7; Telefolmin collection by B. Craig, 1964; Upper Sepik
 collections by B. Craig, 1968 and 1969.

France
Musée National des Arts Africains et Océaniens, 293 Avenue
 Daumesnil, 75012 Paris. Tifalmin cult house facade and
 Telefolmin houseboards, collected 1965.

Germany (West)
Museum für Völkerkunde, Arnimallee 23-27, 1000 Berlin 33.
 Houseboards and shields from Telefomin area collected late
 1960s by B. Craig, on display. Upper Sepik collections of 1968
 and 1969 by B. Craig.

Netherlands
Rijksmuseum voor Volkenkunde, Steenstraat 1, 2300 AE,
 Leiden, Zuid Holland. Collections from 1959 Dutch expedition
 to the western Star Mountains. Houseboards and shields from
 Telefomin area collected in the late 1960s by B. Craig. Upper
 Sepik collections of 1968 and 1969 by B. Craig.

Papua New Guinea
National Museum and Art Gallery, PO Box 5560, Boroko.
 Tifalmin collection of 1964 by B. A. L. Cranstone; Upper
 Sepik collections of 1968 and 1969 by B. Craig; Mountain-Ok
 and Upper Sepik collections of 1972-3 and 1983 by B. Craig.
Baptist Church Museum, Telefomin, West Sepik Province.
 Comprehensive collection of Mountain-Ok material.

Switzerland
Museum für Völkerkunde, Augustinergasse 2, 4051 Basel. Collec-
 tions by Schuster during 1965-7 Swiss expedition to Sepik and
 Telefomin areas.

United States of America
Los Angeles County Museum of Natural History, 900 Exposition
 Boulevard, Los Angeles, California 90007. J. Ward Williams
 collection from Upper Fly and Telefomin area, 1936-7.

Index

Page numbers in italic refer to illustrations

Afek 18, 20, 25
Ancestor cult 20, 23, 27, 31, 60-1
Ancestral bones/relics 16, 20, 23, *23,* 28, *29,* 30, 56-8, *59*
Angkeiakmin 8, 13, 43, 44, 57, *57,* 58, *59,* 60
Arrow designs 31, 46-50, *48,* 52, 54-6, 61, 63, *65*
Arrows 7, 8, 10, 14, *28,* 30, 37-8, 45-8, *46,* 50, 57, 62-3
Atbalmin 7, 9, 13, 17, 30, 50, *51,* 53, 60
Austen, L. 8
Baktamanmin 50, 56
Barkcloth 17, 52
Bark fibres 14, 45
Bark walling/flooring 24, 55
Barth, F. 56
Bimin-Kuskusmin 50
Body armour (cuirass) 14
Bolobip 8, *9, 59*
Bows 14, 45, 46
Bulolengabip *2, 34, 35, 44*
Bultemabip 18, *19,* 31, 44
Campbell, S. 10, 11, *11*
Carving 14, 31, *35, 38, 46,* 53
Cassowary 14, 16, 30, 32, 45, 46, 56
Ceremonies/initiation 14, 18, 20-1, *21,* 23, 27, 60-1
Champion, I. 8, *9,* 10, 28
Chiselling 14, 32, 45, 46
Clubs: palmwood 14, 45, 54-5, *54*
 stone-headed 14, 45
Colours, meaning 56
Colours: black 14, 24, 32, 33, 38, 46, 53, 55, 56
 red 8, 14, 20, 23, 32, 33, 45, 46, 52-6
 white 14, 32, 33, 45, 46, 53, 55, 56
 yellow 32, 33
Cranstone, B. A. L. 3, 37, *43, 44*
D'Albertis, L. M. 63
Design meanings 38, 48-9, 53-4, 56-7, *57,* 60, 61
Dogs 14, 17
Dulanmin *41,* 50
Ear tubes *see* Paint containers
Eliptaman/Elip Valley *26,* 30, *36, 38, 40,* 42

Etching 14, 31, 51, 55, 63
Faiwol 8, 13, 30, 43, 50, 51, 56, 57, 60
Falamin 7, 9, 10, 13, *27,* 30, 42, 43, 58, 60, *61*
Fegolmin 13, *29,* 43, 44, 57, 58, 60
Fighting/warfare 14, 23, 30-1, 37-8, 45-7, *46,* 57, 61, 63
Firemaking techniques 17
Fly River 5, 7, 8, 10, 30, 63
Gardening 17, 23, 27, 30, 38, 60, 61
Hand-drum designs 31, 55-6, 60-1
Hand-drums 14, 21, *21,* 53, 54, 60
Headdress *21, 22*
Highlands 18, 63
Hornbill 27
Houseboard designs 41-3, 50, 55-6, 61-2
Houseboards 8, *9,* 10, 11, *25,* 31, *32,* 33-5, *34, 35,* 37-8, *39,* 40-4, 49-50, 53, 56, 58
Houses 7, 8, 10, 13, 24-5, 27, 30, 31, 32, 33, 37, *38,* 55, 60
 cult/spirit *2,* 8, 17, 18, *19,* 21, 24-5, *26,* 27-8, *27, 28,* 30-1, 43-4, *44,* 57, 58, *59,* 60
 facades *2,* 38, 43-4, *44,* 58
 garden 27, 30, 32
 men's 10, 18, 24, 25, 27, 28, *29,* 30, 33, 37, 56, 58, 61
 women's 18, *23,* 24, *25,* 25, 30, 58, 60, *61*
Hunting 14, 16, 17, 20, 23, 30, 45, 46, 49, 60, 61
Ifitaman 5, 7, 17, 30, 42, 43
Iligimin 17, 30
Inheritance 13, 37
Initiation *see* Ceremonies
Irian Jaya 5, 13, 14, 50, 51, 63
Jew's harp 14
Jorgensen, D. 61
Languages 5, 7, *12,* 13, 48, 49, 50, 62, 63, *65*
Marriage 13, 35
Mianmin 30, 47, 50
Newton, D. 42
North Coast 63
Oksapmin 13, 24, 30, 43, 44, 50, 58
Ok Tedi 8, 18, 30, 31
Om River 13, *41,* 50

Paint container/eartube 31, 51-2, *51*, *52*, 55
Painting 8, 32-3, 45, 52, 53, 55, *55*, 56
Paints *see* Colours
Pandanus 24, 54
Parishes 13, 38
Personal adornment 14
Pig grease 18, 20
Pig husbandry 17, 23, 30, 60, 61, *61*
Pig jawbones/skulls *23*, 30, 56, *59*
Pigs 14, 17, 23, 25, 37, 46, 56, 60
Pig tusks 14
Rat's incisor tool 46, *46*, 51, 54
Roberts, C. 53, 60
Schultze-Jena, L. 7
Seltamanmin 13, 50
Sepik River 5, 7, 8, 9, 10, 18
Shield designs 38, *39*, 40-1, *40*, *41*, 49, 53, 55, *56*, *57*, 61, *62*, 63
Shields 7, 11, *11*, 14, 31, 34-5, *36*, 37-8, *38*, 43, *43*, 47, 50, 57-8, *59*, 62, 63
Smoking tube designs 31, 52, 63, *67*
Smoking tubes 51, 62, 63, *66*
Star Mountains 5, 8, 17
Stone adzes 13, 14, 31, 32, *33*, 63
Strickland River/Gorge 5, 7, 50
String bags (*bilums*) 14, 16, *23*, 57, 59

Sugamin 50
Sweet potato 17, 60
Taro 8, 17, *22*, 23, 54, *54*, 56, 58, 60
Taro knife 54, *54*
Telefol 13, *22*, *25*, *26*, 50, 60
Telefolip 17, 18, *19*, 21, *21*, *23*, 25, *25*, 30
Telefolmin 7, 9, 10, 13, 17, 18, *19*, 21, 23, *25*, *26*, 30, 31, *32*, *33*, 35, 38, *40*, *41*, 42, 43, 47, 53, 56-8, 60
Telefomin 5, 17, 18, 32
Tifal 13, 43, 50, 51, 60
Tifalmin *2*, 13, 30, 43-4, *43*, *44*, 51, 58, *59*
Thurnwald, R. 7, 8, 10
Tobacco 51, 52, 63
Trade 13-14, 33, 46, 47, 53, 56, 63
Tribes *12*, 13, 17, 18, 20, 21, 23, 27, 38
Trophy arrays *23*, 24, *29*, 30, 56
Ubtemtigin *26*, 30
Ulapmin 13, 30, 32, 42, *43*, 58, 60
Upper Sepik 63, *67*
Villages 7, 8, 10, 13, 18, 20, 21, 24-5, *26*, 27-8, 30, 32, 48, 53, 58, 60
West Sepik *62*, *65*, *66*
Williams, J. W. 10, *11*, 32
Wopkeimin 13, *15*, 18, *19*, 30, *41*, 43-4, 50, 53, 58, 60